IMAGES
of America

FORT GREENE

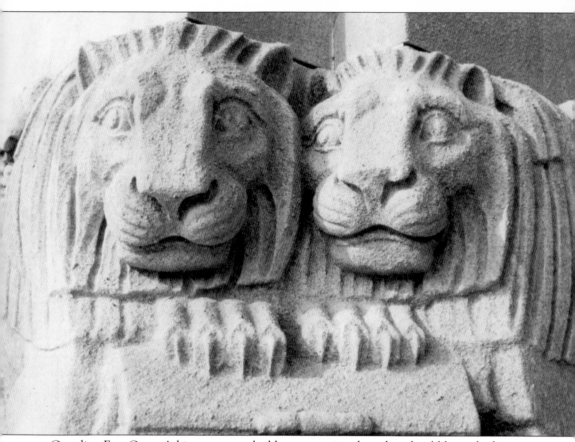

Guarding Fort Greene's history as a valuable treasure is a duty that should be etched in stone. That is exactly the concept of these two intrepid lions at the portal of the Williamsburgh Bank in Hanson Place—guarding the valuable treasury box. (Author's photograph.)

ON THE COVER: In this 1930s photograph, a man peers out from the northwest corner of Navy Street and Park Avenue, where today's Brooklyn Queens Expressway (BQE) bombards its cross-traffic overhead. The view looks westerly where Park Avenue becomes Tillary Street. A sailor, located center in a dark uniform, from the Navy Yard saunters toward downtown Brooklyn. The Raymond V. Ingersoll Houses now stand at the left. (MTA Bridges and Tunnel Special Archive.)

IMAGES of America

FORT GREENE

Howard Pitsch

ARCADIA
PUBLISHING

Published by Arcadia Publishing
Charleston SC, Chicago IL, Portsmouth NH, San Francisco CA

Printed in the United States of America

Library of Congress Control Number: 2009934841

For all general information contact Arcadia Publishing at:
Telephone 843-853-2070
Fax 843-853-0044
E-mail sales@arcadiapublishing.com
For customer service and orders:
Toll-Free 1-888-313-2665

Visit us on the Internet at www.arcadiapublishing.com

To the late Alfredo Muglio, whose prescient efforts toward the preservation and renewal of Fort Greene created its own dynamic.

CONTENTS

ACKNOWLEDGMENTS

In 1973, Herbert Scott-Gibson took Fort Greene in his palm and molded it into a patty of pride for what people in downtown Brooklyn cherish as home. Scott-Gibson, an African American of envious musical and artistic talent, knew fully well that historic preservation fosters people's pride and responsibility in a multiethnic enclave. From his originality came resurgence in our neighborhood, as well as creation of a productive nonprofit, the Fort Greene Association.

All hail to Paul Palazzo, chair of the Fort Greene Association, Inc., whose persevering fingertips configured this book. For financial and moral support there were resolute believers such as Richard Burlage, Elyse Newman, and Allen Hobbs. Special thanks to president of the Brooklyn Academy of Music (BAM), Karen Hopkins, and archivists Sharon Lehner and June Reich; Deborah Schwartz and Julie May, Brooklyn Historical Society; Daniella Romano and Sara Fitzpatrick at the Brooklyn Navy Yard (BNY); Carrie Strumm at the New York Transit Museum; Laura Rosen at MTA Bridges and Tunnels Special Archives; Joseph Coen at the Diocese of Brooklyn Archives; and Liliy Magalnik of Brooklyn Tech Alumni Association. To those who indicated temporal interest: Roisin Wisneski, Jack Termine, Mark Jordan, Monica von Halle . . . and to others who offered condolences. Thank you all so very much!

FOREWORD

The wonderful images contained in this book are remembrances of an era gone by. One realizes they are the very foundation upon which the current Fort Greene—a neighborhood with a long, proud, and sometimes difficult past—is built.

With this past in mind, I hope that you, the reader, look forward to what the future will bring and the ways our rediscovery of the past, through these vivid and often surprising photographs, continue to help us shape the future.

Most important, this is a book to enjoy and help us all to discover where we fit into and connect in the small world of Fort Greene, the larger picture of the history of Brooklyn and New York City, and to the world itself. Thanks to all who have come before and all who will come after to understand and contribute to this great Brooklyn neighborhood.

—Paul Palazzo
Fort Greene Association Chair, 2008–2010

INTRODUCTION

Convoluted, the saga of Fort Greene decodes a human genome that comprises the patriotism of our forbears, the might of men, horses and steel, a spectrum of performing arts, and an architectural scene that makes the eye smile. See it here, maybe even hear it as the elevated train screeches by, or just simply enjoy it as people of Fort Greene do today.

One virtually weeps, however, at the absence here of so many exciting scenes that could not be shown because of the exigencies of the clock, cash, copyrights, and low computer digital quality. But leaf on and hopefully come away with a sense that the thrust of Fort Greene in downtown Brooklyn offers a fortunate future for our kin.

Inevitably, in a work such as this that covers a broad span of time, there may be oversights that need emendation. If so, the author pleads mea culpa and asks the reader to send corrections or comments to howard@historicfortgreene.org.

One

BAY AND HILL

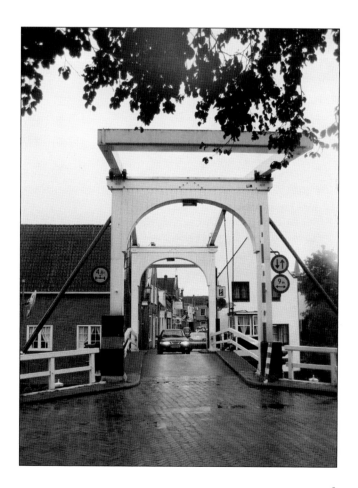

Pictured is the Breukelen Bridge in the Netherlands province of Utrecht. Its population is 15,000, scarcely the size of Brooklyn, whose name was taken from the Dutch town more than 350 years ago. (The *Brooklyn Paper.*)

Pictured is the main square in Breukelen, the Netherlands, from where Fort Greene got its name. Breukelen may soon be incorporated into a larger town, just as Brooklyn got spooned into New York in 1898. (The *Brooklyn Paper.*)

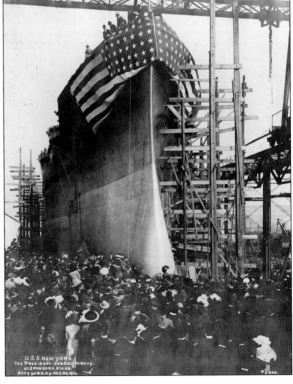

In top hats and finery, or in uniforms, an assemblage gathers for the launch of the proud USS *New York* in 1912. Pictured near the end of his term, Pres. William Howard Taft, who smashed the Champagne bottle, is the heavyset man seen close to the bow. (BNY archives.)

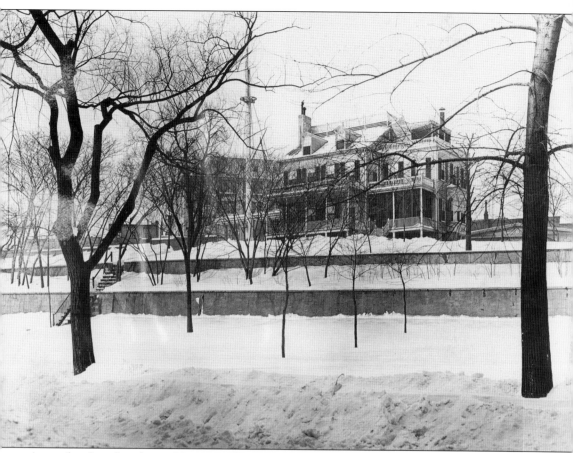

Atop a height referred to as Vinegar Hill remains the original Navy Yard commandant's house, built in 1805. An inspired clapboard pile of Georgian or Federal influence, it may have been designed by Charles Bullfinch, an early U.S. Capitol architect. This snowy scene of the landmarked house, now in private hands, dates from 1914. (BNY archives.)

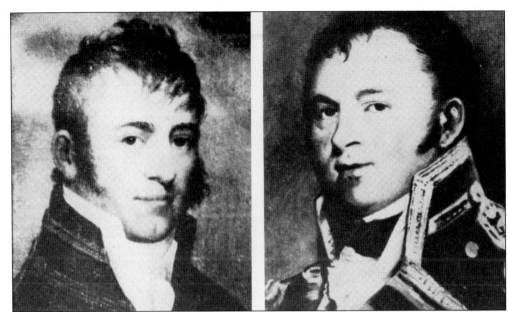

Lenape Indians sold a plot along Wallabout Bay to Huguenot Joris Jansen de Rapaelje in 1635, and from Rapaelje heirs to John Jackson in 1781. Jackson built boats there until selling his business to Pres. John Adams's government in 1801. Thus began the Brooklyn Navy Yard. Its first commandant in 1806 was Lt. Jonathan Thorn, at left, whose successor, upped in rank and regalia, was Capt. Isac Chauncey. (BNY archives.)

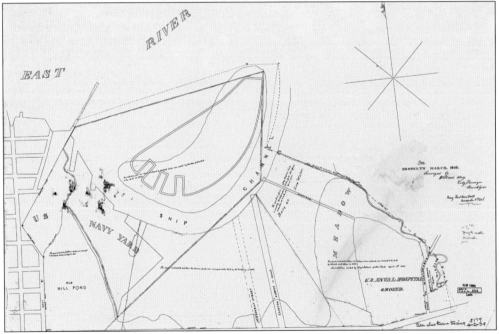

An 1846 map of the Brooklyn Navy Yard reveals the first dry dock's location, mid-center left. The channel around the half-moon plot at the top was where British prison ships were moored during the Revolutionary War and where perhaps 11,500 American patriots and other maritime nationals died of starvation and pestilence. Some of their remains are now in a crypt in Fort Greene Park. (BNY archives.)

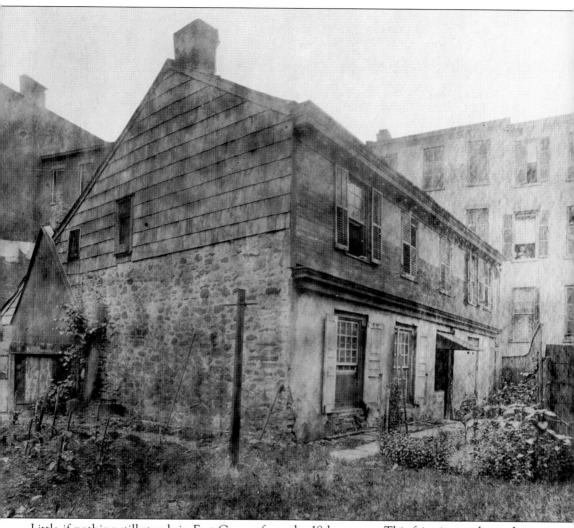

Little if nothing still stands in Fort Greene from the 18th century. This faint image shows the home of the Provoost family, most likely of Dutch ancestry. It stood on the east side of Cumberland Street between Park and Flushing Avenues, where the Cumberland Packing building, which is better known for its pink packets of Sweet'N Low, now stands. (BNY archives.)

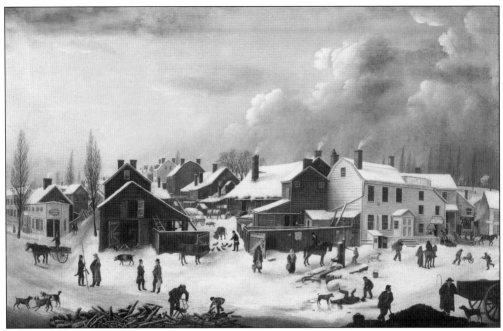

Scarcely a painter, Francis Guy (1760–1820) arrived here from England in 1795, trained as a tailor and silk dyer. Initially from Baltimore, he came to Brooklyn by 1817 with a special fondness for capturing the sights of Fort Greene near Front and Main Streets in oils. In this winter scene, a man and boy gather firewood for the hearth, while another man slips on the ice. (Brooklyn Museum.)

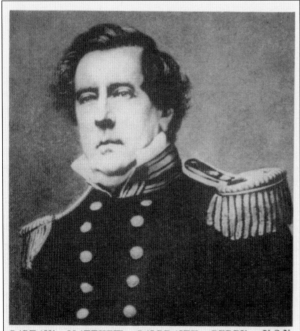

CAPTAIN MATTHEW CALBRAITH PERRY, U.S.N., served as Commandant of the New York Navy Yard from June, 1841, to July, 1843. In later years, he became famous as the Commodore Perry who led the expedition to Japan.

From 1841 to 1843, Matthew Perry was commandant of the Navy Yard, under whose aegis the first dry dock was begun, made of granite blocks brought down from Inwood. The 320-foot-long dry dock took 10 years to build. Perry went on to wive it wealthily to August Belmont's daughter before his naval fleet sailed easterly to open up Japan to foreign trade in 1853. (BNY archives.)

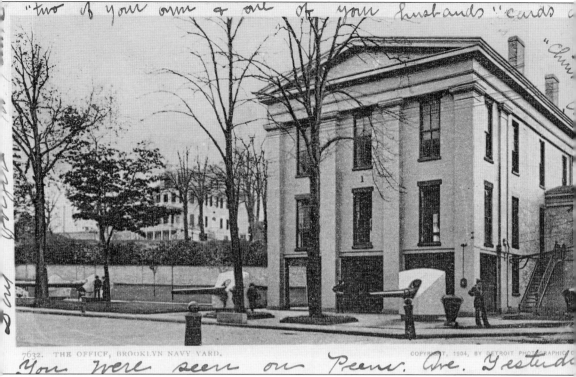

A 1904 postcard shows the neoclassical Lyceum that Commodore Matthew Perry developed at the Brooklyn Navy Yard in 1833 before he became the yard's commandant. Its aim was to "promote the diffusion of useful knowledge." James Fenimore Cooper frequently contributed to the Lyceum's *Naval Magazine*. (BNY archives.)

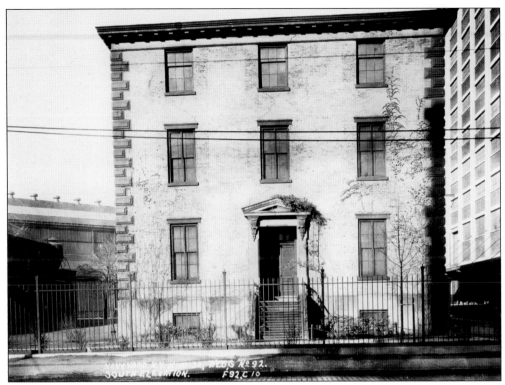

Known at the Navy Yard as Building 92, this home from 1857 quartered U.S. Marine commanders who oversaw the Navy Yard's security. It has become a valuable naval history center. Philadelphia architect Thomas U. Walter, the fourth architect of the nation's capitol, designed the house. (BNY archives.)

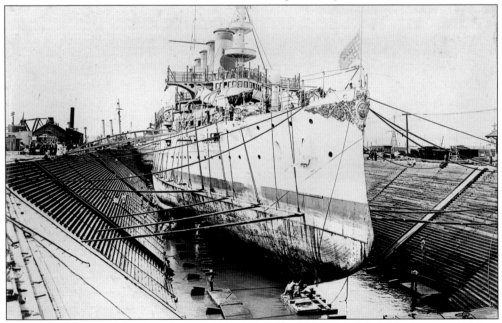

The huge USS *Colorado* rests in dry dock in 1915, undergoing repairs. It looks figuratively like a "duck out of water." (BNY archives.)

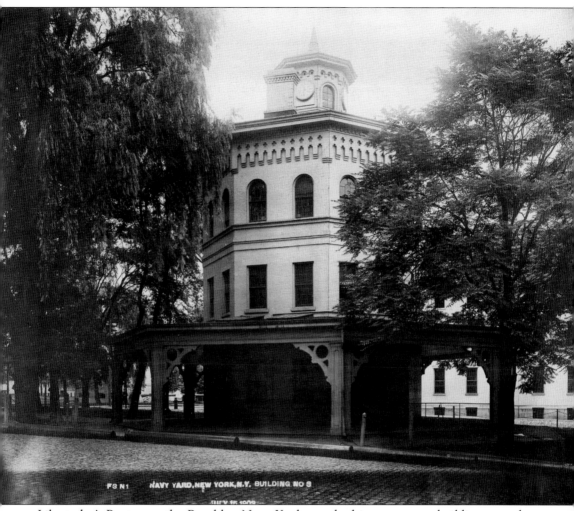

Like today's Pentagon, the Brooklyn Navy Yard once had its octagon, a building near the commandant's house, seen here in 1903. Though long gone, this oddity may have served as administrative quarters for managing the yard. (BNY archives.)

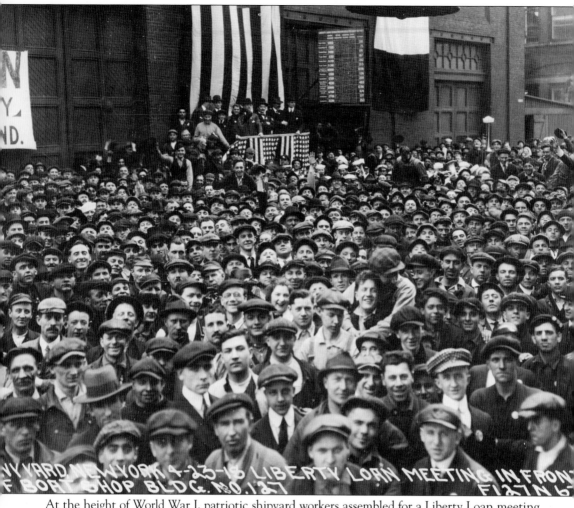

At the height of World War I, patriotic shipyard workers assembled for a Liberty Loan meeting in front of the Brooklyn Navy Yard's boat shop. Turnout was terrific, as seen from this 1918 photograph. (BNY archives.)

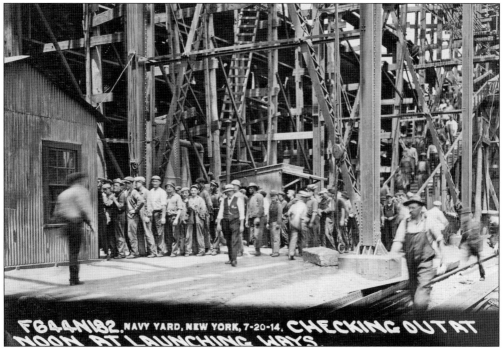

Men are pictured in 1914 leaving the launching ways, huge scaffolding that supported a ship while being constructed. It also provided platforms for successive work as the vessel progressed. (BNY archives.)

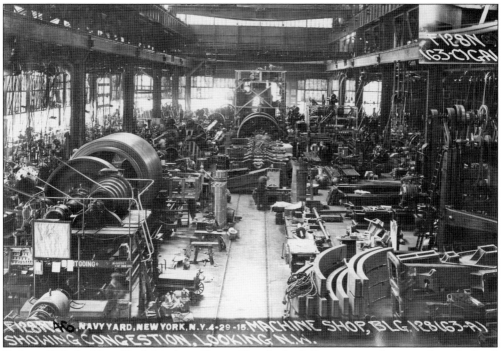

Built in 1899, the Navy Yard's Machine Shop seldom had a dull moment as ships were launched and others arrived for repairs. Men, seen here in 1915, are working on large power gear. (BNY archives.)

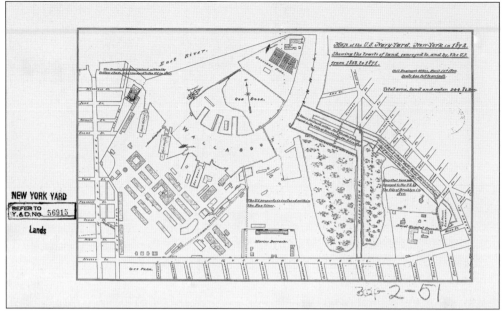

An 1872 map of the New York Naval Shipyard—commonly named the Brooklyn Navy Yard—shows many additional facilities. A number of these were occasioned by the Civil War. It was here that the USS *Monitor*, built in Greenpoint, was outfitted and sent to battle the Confederate *Merrimac* in Hampton Roads, Virginia. (BNY archives.)

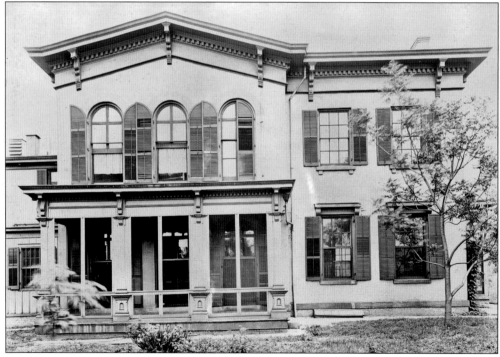

Serving on battleships in close quarters could sometimes easily spread contagious diseases, such as typhoid. To help those afflicted men undergo treatment, "Contagious Wards" were specially built at the Naval Hospital, as was this one seen in 1915. The building is now gone. (BNY archives.)

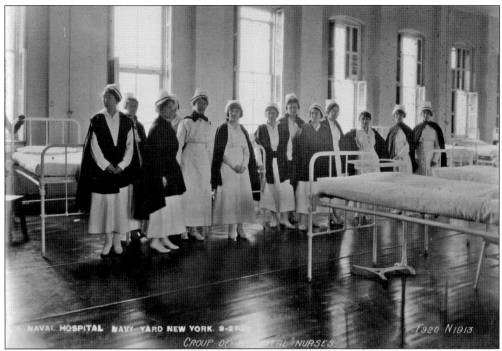

Well organized and disciplined, nurses at the Naval Hospital in 1920 posed for their picture in one of the hospital wards. (BNY archives.)

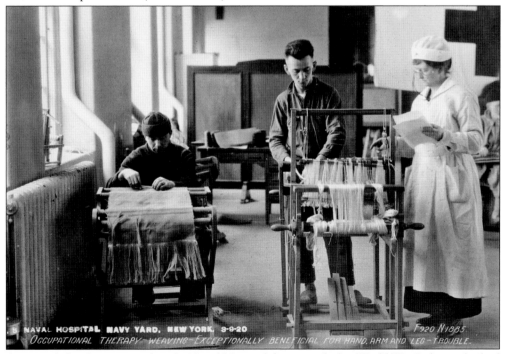

As wounded sailors returned to the Naval Hospital during and after World War I, those who had arm and hand injuries were given classes in weaving. It was a way of retraining their limbs for manipulative dexterity. (BNY archives.)

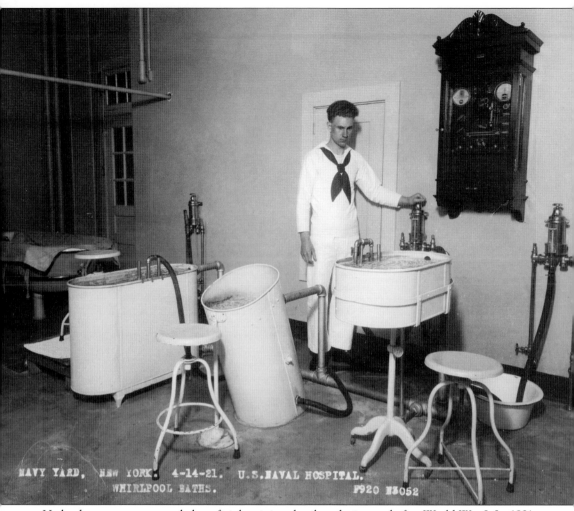

Hydrotherapy was extremely beneficial to injured sailors during and after World War I. In 1921, a Naval Hospital aide prepares a whirlpool basin for a man on the mend. (BNY archives.)

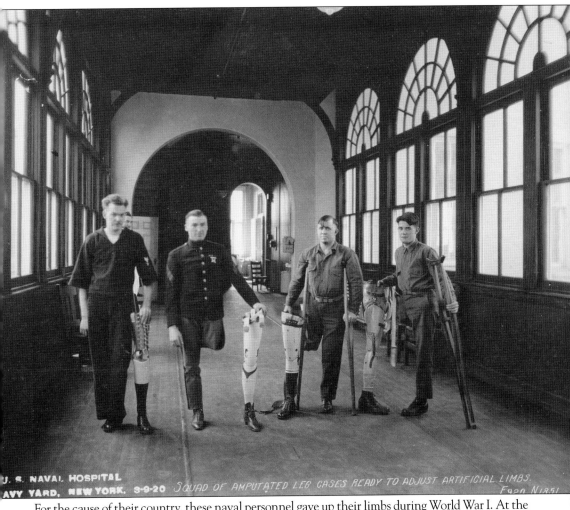

For the cause of their country, these naval personnel gave up their limbs during World War I. At the Naval Hospital, they were fitted with prostheses designed up to that period. (BNY archives.)

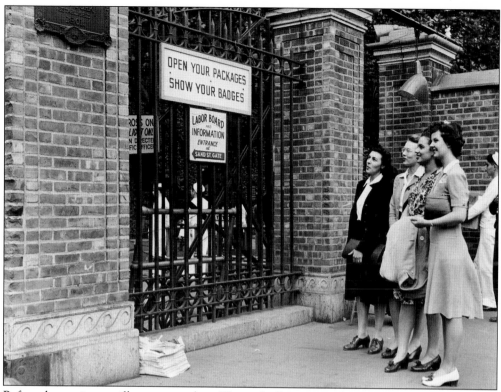

Before electronic surveillance gates, these "Rosie the Riveters"—the first-ever women to work at the Brooklyn Navy Yard during World War II—had to open their handbags for security reasons. (BNY archives.)

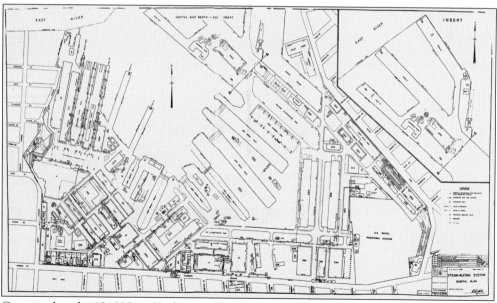

Compared to the 1846 Navy Yard map, this 1944 World War II schematic shows how mightily the facilities grew. Workers alone—women now included—grew from 10,000 in 1938 to 70,000 by the war's end. (BNY archives.)

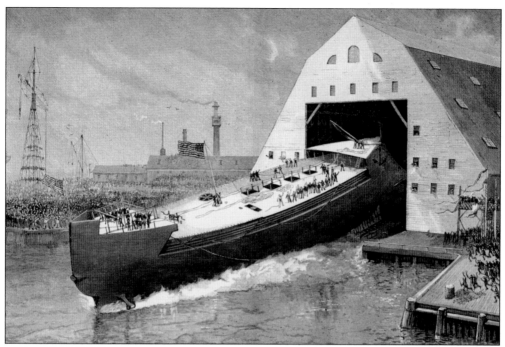

After the USS *Maine*'s birth, seen here at the Brooklyn Navy Yard in 1890, she was later sunk in the Havana Harbor during the Spanish-American War. No other ship ever launched surpassed her in size up to that time. (*Harper's Weekly*, October 29, 1890.)

When the USS *Missouri* was completed in 1944, then senator Harry Truman accompanied his daughter Margaret to the Navy Yard, where she launched the battleship. Aboard this behemoth a year and a half later, the Japanese surrendered to Gen. Douglas MacArthur, ending World War II. Truman was then president. (BNY archives.)

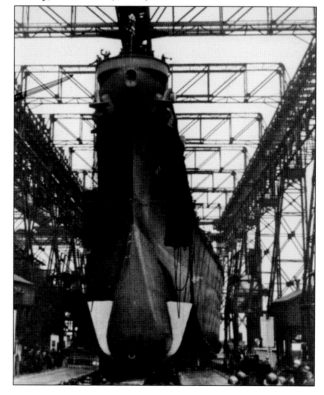

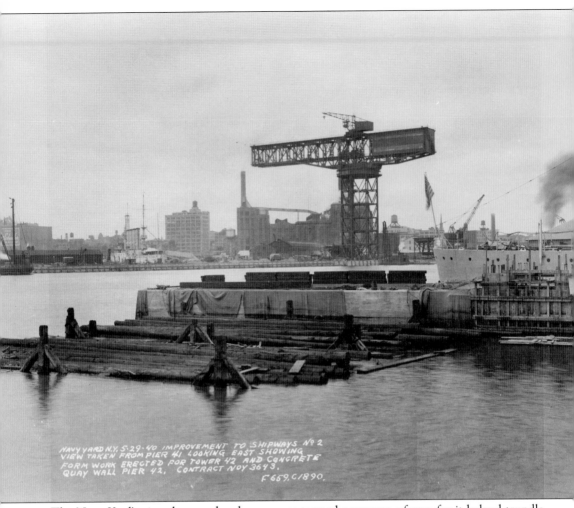

The Navy Yard's giant hammerhead crane was termed a weapon of war, for it helped trundle supplies for building World War II battleships. It could lift 350 tons when stretched out to a radius of 150 feet. (BNY archives.)

The British held American prisoners after 1776 until the Revolutionary War ended on this decrepit ship, the *Jersey*, and other vessels in Wallabout Bay. Some 11,500 prisoners died on board of disease and starvation. (Fort Greene Park Conservancy.)

Wallabout Bay, derived from the Dutch *Waal Boght*, means "bend in the river." In 1894, the City of Brooklyn created the Wallabout Market, a major meat and produce resource. Navy Yard expansion in World War II forced the market to close. (BNY archives.)

THE PRISON SHIP "JERSEY."

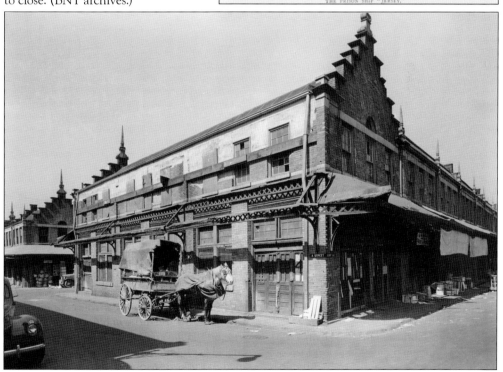

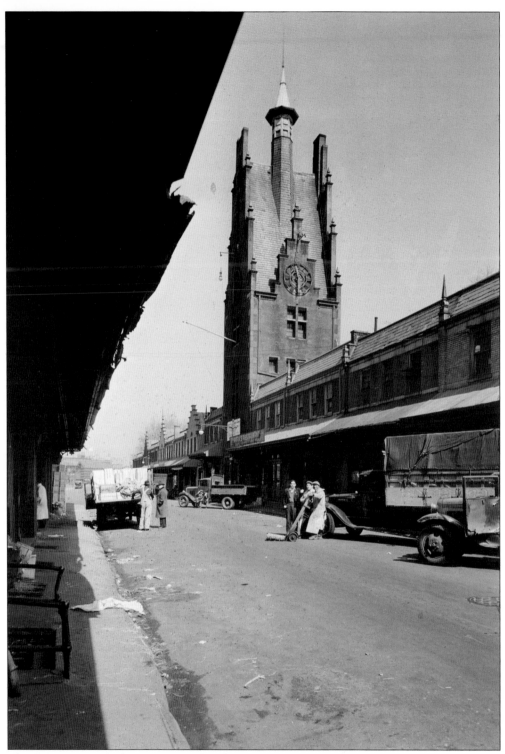

This Renaissance clock tower counted the hours over the Wallabout Market at the Navy Yard in the 1900s. William Tubby was its mastermind. (MTA Bridges and Tunnels Special Archive.)

Two

DOWNTOWN DIGS

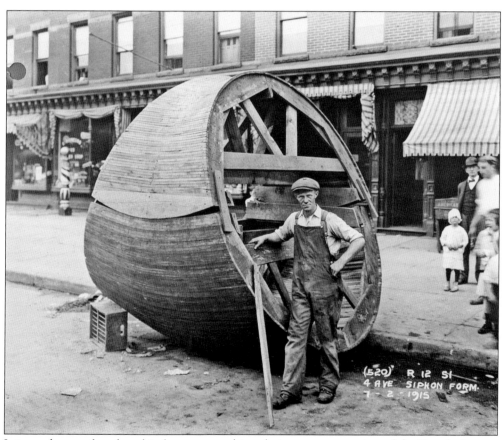

It is not known for what this form was used in relation to construction of the Fourth Avenue subway line (N and R). It is listed in 1915 as a "siphon," though it might have been a mold for pouring concrete to create a tunnel. Of course, this one would be too small for a train to pass through. (New York Transit Museum.)

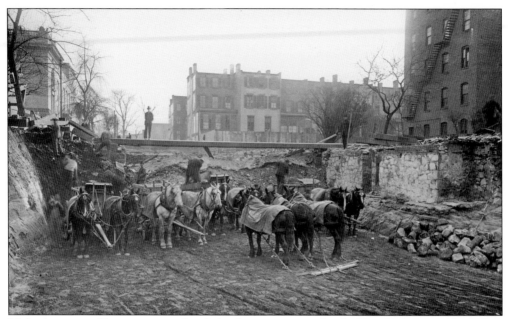

Multiple teams of horses wait as they helped in excavating for the Fourth Avenue subway line (now N and R) in 1911. This scene looks south from Fulton Street along Ashland Place and across Lafayette Avenue to the western facade, on the left, of the Brooklyn Academy of Music. (New York Transit Museum.)

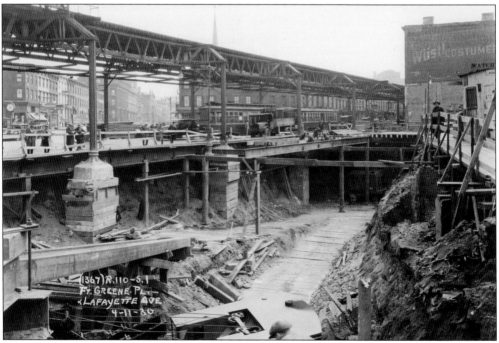

Even as the Fulton El continued in 1930 and the Fulton trolley commanded the street, a subway tunnel was being excavated for the Independent (A and C) line. This view looks east from Fort Greene Place, with Fulton Street angling right and Lafayette Avenue on the left. The former spire of the Lafayette church is at top center. (New York Transit Museum.)

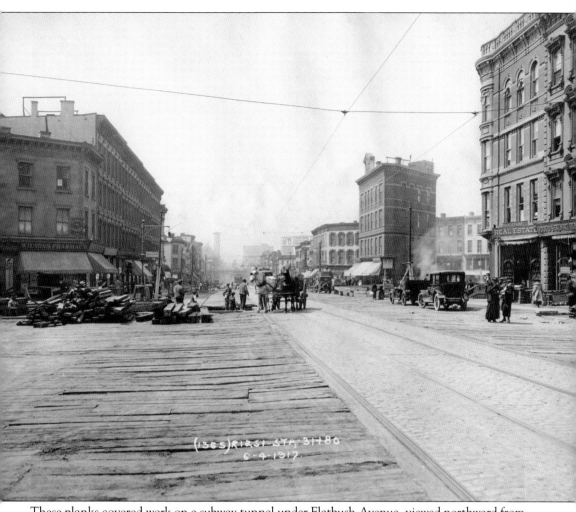

These planks covered work on a subway tunnel under Flatbush Avenue, viewed northward from about Fulton Street. Horse carts aided the project in 1917. (New York Transit Museum.)

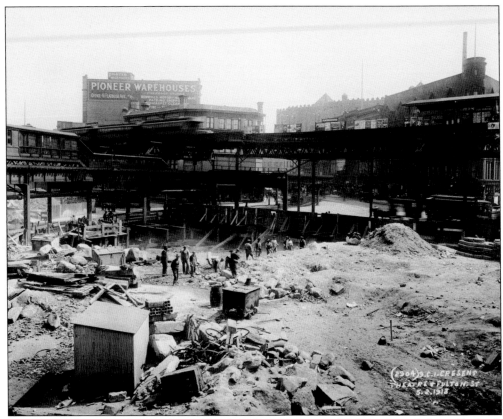

Two elevated lines, Fulton and Brooklyn-Manhattan Transit (BMT), crossed along Flatbush Avenue at Fulton Street in 1918, even as tunneling was being dug for the Independent subway. Seen at the top is the Pioneer Warehouse that remains extant. Opposite that was the Crescent Theatre at Livingston Street. (New York Transit Museum.)

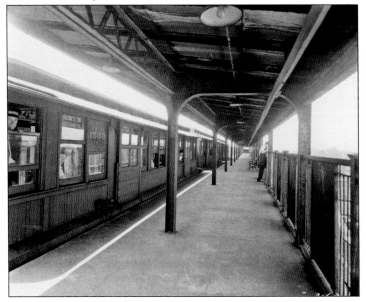

Notice that this Fulton elevated car in 1952 had no graffiti, no gum spots on the platform, and no litter along the way. (New York Transit Museum.)

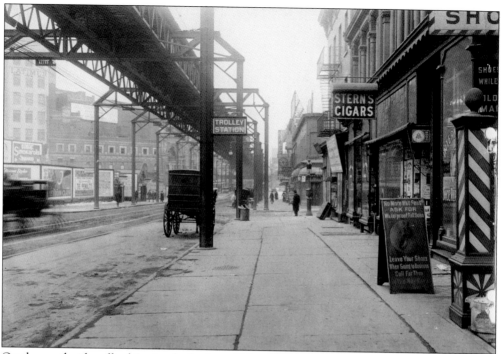

On the north sidewalk, this view looks down Fulton Street from St. Felix Street toward Ashland Place. Under the El at left is the string of small square windows that were in the facade of the Orpheum Theatre at 578 Fulton Street, torn down in 1953. Another theater, the Montmartre at 590 Fulton Street, died the same year. (New York Transit Museum.)

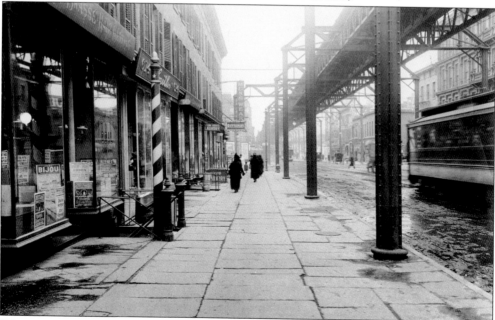

Women's coats were long in 1916, as seen here on the south side of Fulton Street from St. Felix Street westward to Ashland Place and beyond. The name Fulton received a workout as the name of the street, the overhead El, and the trolley line below. (New York Transit Museum.)

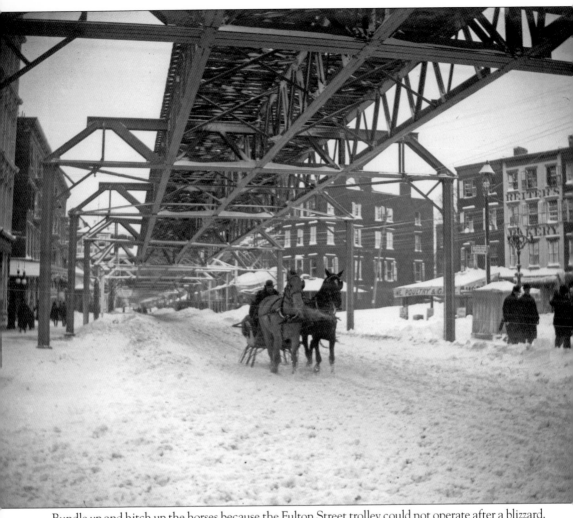

Bundle up and hitch up the horses because the Fulton Street trolley could not operate after a blizzard. Life quieted down at that time under the Fulton Street Elevated. (Brooklyn Historical Society.)

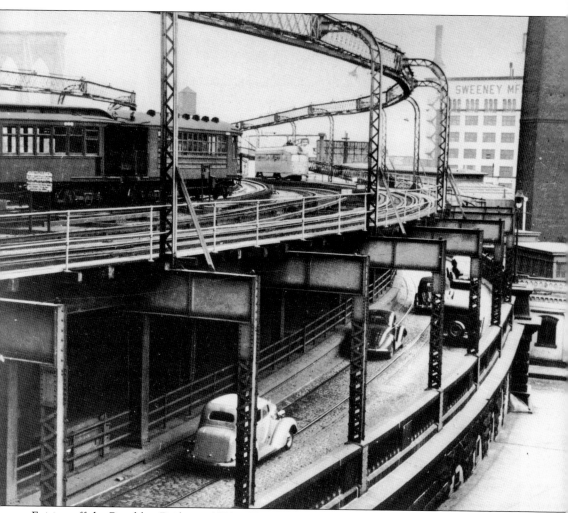

Exiting off the Brooklyn Bridge in 1934, a BMT train is on its way toward Fort Greene. All this trestle work is long gone. (New York Transit Museum.)

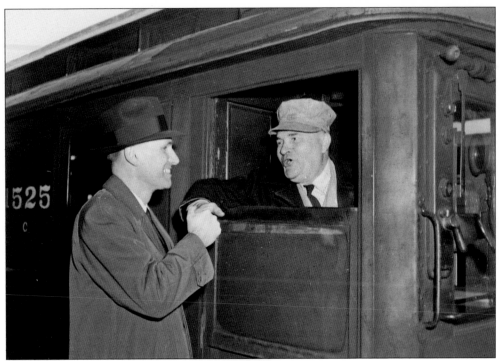

Motorman Frank Brown's last trip was on the old elevated Fulton line, perhaps in the 1940s. A rider congratulates him about his future no-stop-and-go retirement. (New York Transit Museum.)

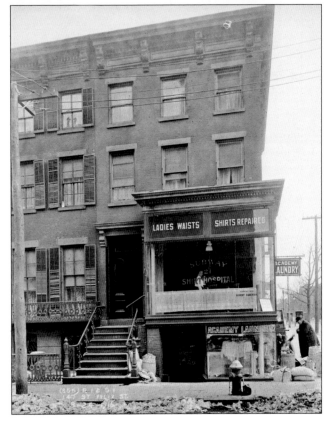

This picture dates to 1916, just a year before the building's entire front collapsed into a subway hole. The Academy Laundry was at the northeast corner of St. Felix Street and Hanson Place. A sign on the window says "Shirt Hospital," where men took their frayed collars to be turned around for another day. (New York Transit Museum.)

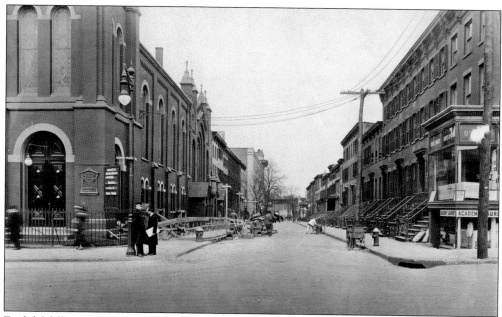

Faithful followers began a Central Methodist Church in 1857 at Hanson Place on the northwest corner of St. Felix Street, opposite the Academy Laundry. By 1874, the members outgrew that building, tore it down, and constructed another in the Romanesque style seen here. It lasted only 50 years because subway construction weakened it, necessitating the present art deco-Gothic church erected in 1929. (New York Transit Museum.)

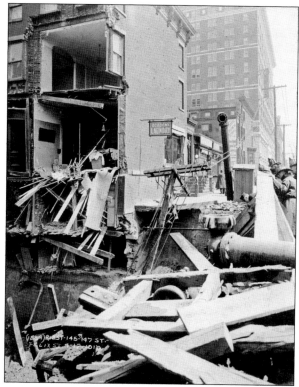

Timber shoring for the 60-foot-deep D line subway tunnel collapsed in 1917 at the intersection of St. Felix Street and Hanson Place. Marguerite Shephard, stitching a collar at the "Shirt Hospital" of the Academy Laundry, came sliding out when the facade fell into the hole, and she lived. A St. Felix Street resident, actor Clair Dorkery, disappeared below for three days until his corpse was found. (New York Transit Museum.)

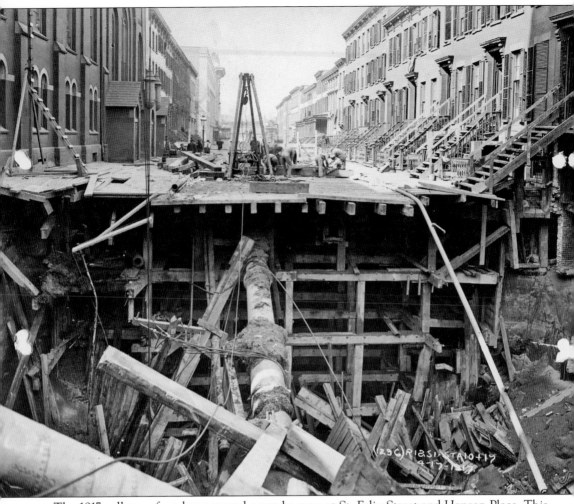

The 1917 collapse of a subway tunnel caused a mess at St. Felix Street and Hanson Place. This view looks north along St. Felix Street. The foundation of the second of three Central Methodist Churches, the one at left built 1874, was so compromised that the edifice had to be demolished in 1929. (New York Transit Museum.)

Numbers 119 and 121, on the east side of St. Felix Street between Lafayette Avenue and Hanson Place, were built for speculation in 1859 by a mini-Donald Trump, Effingham Nichols. Their nifty front porches, here in 1916, would not last because of subway and water main debacles under the street. (New York Transit Museum.)

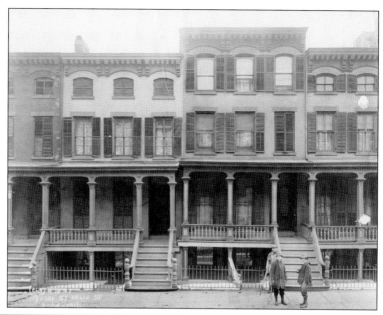

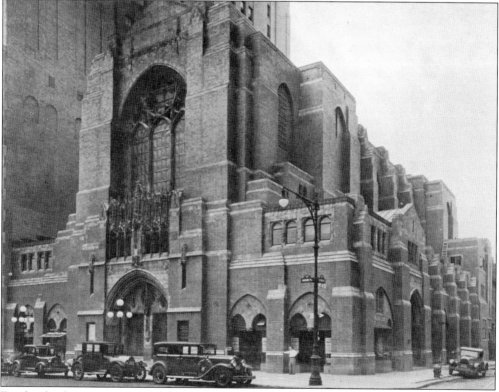

For the third sanctuary since 1857, Lessing Whitford Williams bashed an architectural piñata in drafting this stunningly bulldog-squat, art deco Gothic Hanson Place Central United Methodist Church in 1929. Next to the Williamsburgh Bank, the church looks out at the Hanson Place and St. Felix Street corner. Its east windows portray biblical saints; the west depicts the seculars: Lincoln, Beecher, Joan of Arc, etc. (Brooklyn Historical Society.)

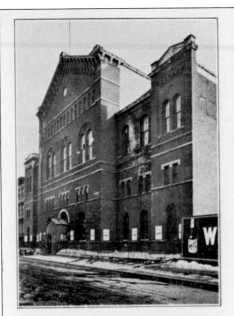

The first armory of the New York State 13th Regiment was on Cranberry Street near Henry Street. Their second armory, built in the mid-19th century, was on Hanson Place opposite St. Felix Street. In the 1890s, this building was abandoned and razed as plans began for the 1906 Long Island Railroad Terminal. A third 13th Armory, a huge hulk, followed at Bedford and Atlantic Avenues. (Brooklyn Historical Society.)

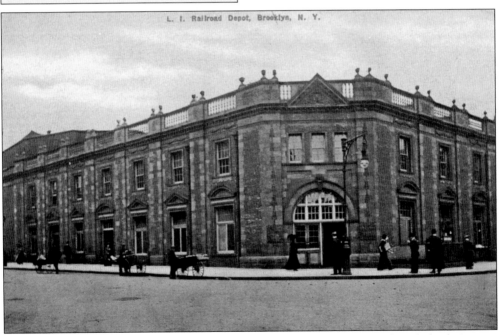

In its prime after being opened in 1906, the Long Island Railroad Terminal at Flatbush Avenue and Hanson Place funneled commuters until the ball fell in 1985. H. F. Saxcelbey designed the neo-Renaissance terminal to wrap around a corner. Several Fort Greeners now have its terra-cotta festoons in their gardens. (Brooklyn Historical Society.)

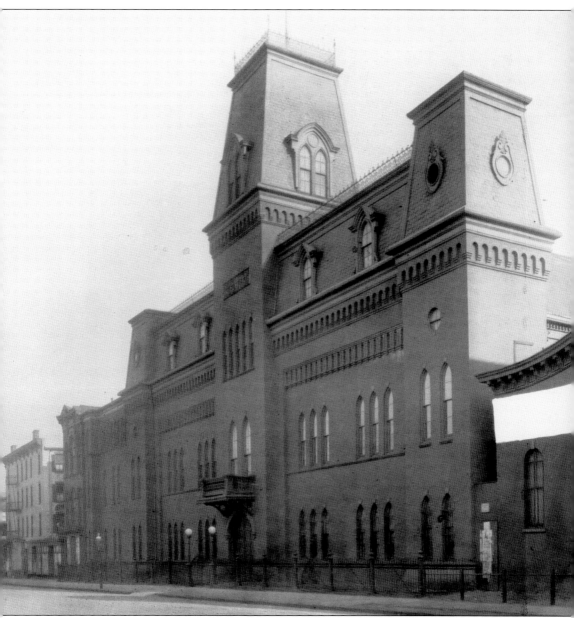

Such a gorgeous carbuncle was the 23rd New York Regiment's armory of 1873, designed by William R Mundell. French Second Empire in style, its mansarded central tower walloped Clermont Avenue between Willoughby and Myrtle Avenues. "The flower of Brooklyn's youth" described the men who trained here in a drill hall, 180 feet long under curved trusses. (New York State Office of Parks and New York State Military Museum, Saratoga.)

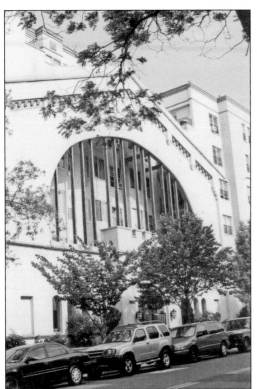

Architect Floyd Peterson devised a sort of aerodrome look in 1911, when the 23rd Regiment Clermont Armory was reconstructed. It served for military use until 1964 when it became a New York City Police facility for training cadets. In the 1990s, the building was totally redesigned as condos, which are seen today. Several original, curved drill hall trusses were left over the inner courtyard, rather like a naked umbrella. (Author's photograph.)

A large boxing hall once stood just south of the 1873 23rd New York State Regiment Armory on Clermont Avenue near Willoughby Avenue. The hall hosted a variety of activities, including ice-skating and religious assemblies. (Brooklyn Public Library.)

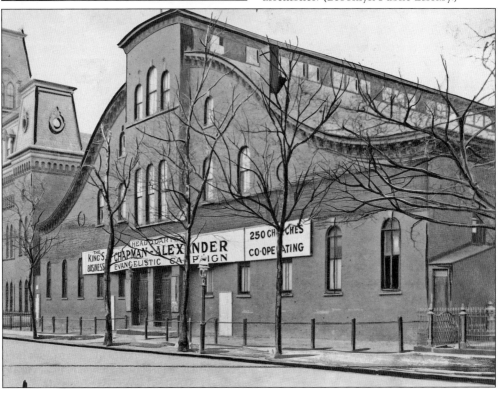

Quite distinctive is the articulated neo-Greco building at 236–238 DeKalb Avenue at Clermont. Its original bracketed storefront nicely echoed the arched, surmounting cornice. The well-known Parfitt brothers designed it all in 1876 for builder J. W. Dearing. The Parfitts also created the masterfully beautiful St. Francis Xavier Roman Catholic Church at Sixth Avenue and Carroll Street in Park Slope.

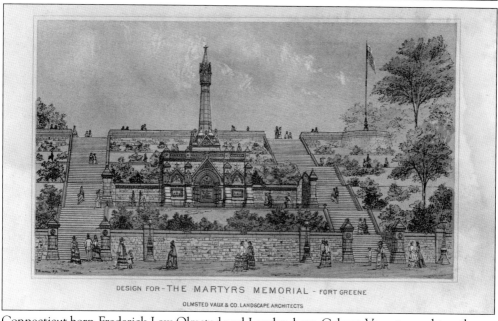

Connecticut-born Frederick Law Olmsted and London-born Calvert Vaux teamed together as landscape architects nonpareil after the mid-19th century. Noted for their Central and Prospect Parks, in 1867 they took on Fort Greene Park, which poet Walt Whitman had earlier instigated. Their plan for the Prison Ship Martyrs was a Gothic memorial, although never completely fulfilled. (Brooklyn Historical Society.)

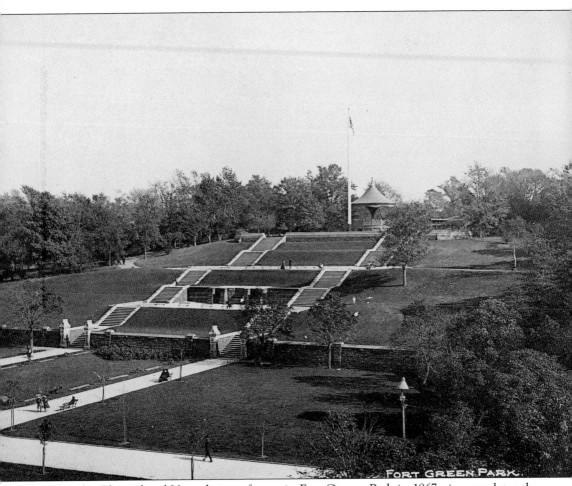

After the Olmsted and Vaux design of steps in Fort Greene Park in 1867, six years later the remains of the Prison Ship Martyrs were brought from their earlier tomb at Front Street and Hudson Avenue. Their crypt is in the side of the park's hill. A conical-shaped speaker's platform was also erected at the top of the hill. (Brooklyn Public Library.)

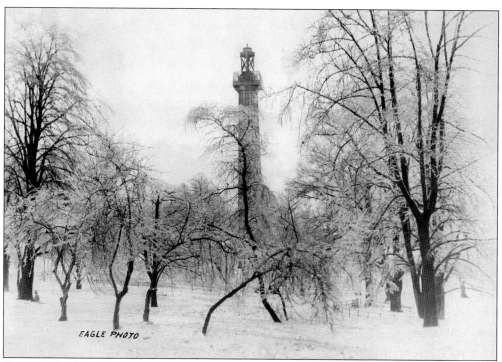

EAGLE PHOTO

A year before New York governor Al Smith began his (losing) campaign for the American presidency, this winterscape of Fort Greene Park was captured. Under its somnambulant blanket, the park bids early welcome to children on sleighs, while the brazier atop the Martyrs Monument is dimmed. It was designed by Adolph Weinman, who also created the famous 10¢ piece, or dime, with the face of Mercury. (Brooklyn Public Library.)

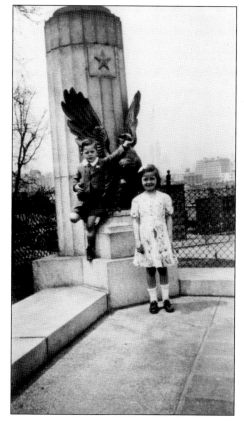

Four bronze eagles at the Fort Greene Martyrs Monument have always delighted children. Their symbolism is quite adult, however, with their wings akimbo they express a fierce protectiveness of their young hatchlings, as well as provident respect for the 11,500 American patriots who lie in a crypt below the monument. (Author's photograph.)

45

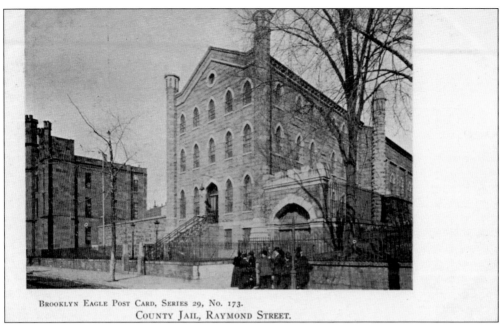

County Jail, Raymond Street.

Better than a flophouse, free lodging was always provided by the jail at Willoughby Avenue and Raymond Street, now called Ashland Place. It started with crime-free talent as a Gothic fortress in 1838 by architect Gameliel King, who also designed the Brooklyn Borough Hall. First for male inmates, the jail added a wing for women in 1839. Long outmoded, the jail was closed in 1963. (Brooklyn Historical Society.)

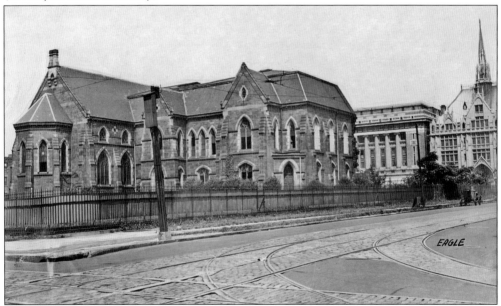

The first Roman Catholic bishop of Brooklyn in 1853 was John Loughlin, who felt cathedral-needy. So, he bought land in 1865 along Lafayette and Vanderbilt Avenues that was once owned in 1641 by Peter Monfort under a patent from Dutch governor Gen. Willem Kieft. To tide him over as a seat for his see, the bishop had St. John's Chapel built as a pro-cathedral in 1878, sited where Bishop Loughlin High School now stands. (Brooklyn Public Library.)

Twelve years after the founding of the Roman Catholic Diocese of Brooklyn in 1853, Patrick Keely was engaged to design a new Gothic Cathedral of the Immaculate Conception. The cathedral, in "one of the most aristocratic quarters of Brooklyn," was located at Lafayette Avenue between Clermont and Vanderbilt Avenues. Later it was felt Fort Greene could not sustain a cathedral, and funds were used for the Queen of All Saints Church and School. (Diocese of Brooklyn.)

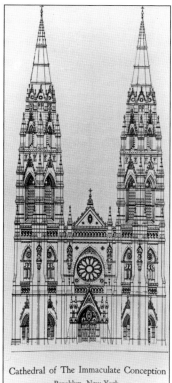

Cathedral of The Immaculate Conception
Brooklyn New York

By creating the home, center, of the Roman Catholic bishop of Brooklyn in 1889, Patrick Keely followed by designing St. John's Chapel, seen at left along Clermont Avenue at Greene Avenue. The home had 40 rooms and is now used as a residence for young men. The Episcopalian Church of the Messiah and Incarnation spire on Greene Avenue was destroyed by fire. (Brooklyn Historical Society.)

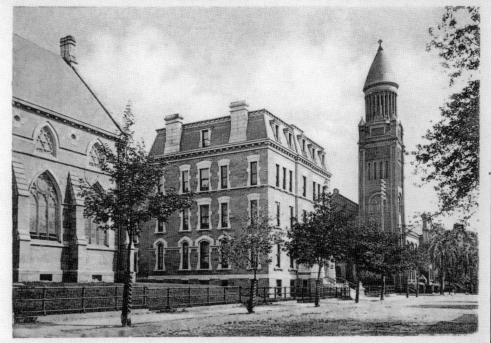

ST. JAMES R. C. CATHEDRAL. BISHOP'S RESIDENCE. CHURCH OF THE MESSIAH.
CLERMONT AVENUE COR. GREENE AVENUE.

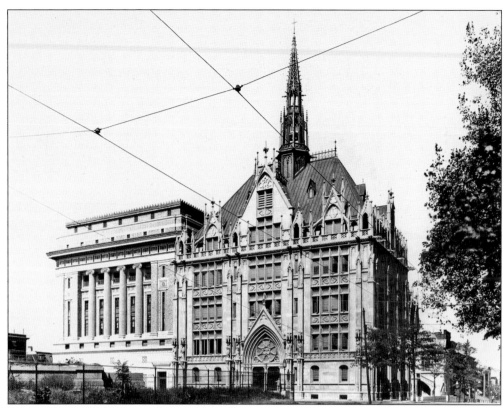

Inspired by the 13th-century Sainte-Chapelle in Paris, architects Gustave Steinback and Robert Reilly conceived an excitingly flamboyant Gothic Queen of All Saints Roman Catholic Church, dedicated in 1913. The Masonic Temple, left, with polychromed terra-cotta and Ionic pilasters, is the craft of Austin Lord and James Hewlett in 1906. Lord also worked with McKim, Mead, and White on the Brooklyn Museum. (Diocese of Brooklyn.)

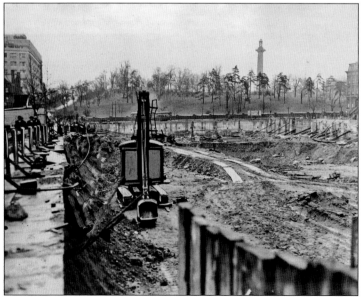

The Wisconsin Glacier dumped a zillion tons of moraine 15,000 years ago, and men started digging it all out in 1929 for the Brooklyn Technical High School in Fort Greene Place. Mayor Jimmy Walker broke ground for the school at that time. Massive in bulk, it was designed in a Collegiate Gothic manner by the architectural firm of Francis X. Gina Partners. (Brooklyn Public Library.)

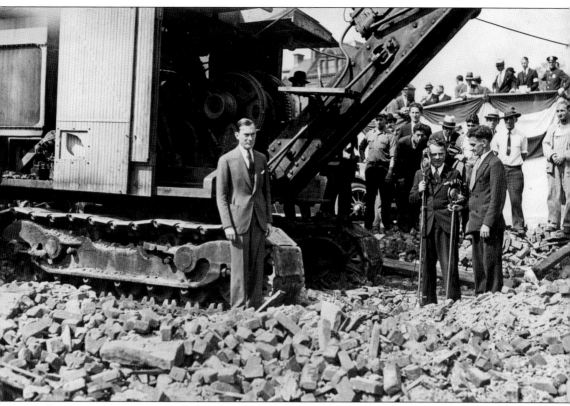

Gallivanting mayor Jimmy Walker, at the mechanical scoop, performed the honors at the excavation for the Brooklyn Technical High School. It would serve as a replacement of an earlier school on the Flatbush Avenue Extension. (Brooklyn Tech Alumni Association.)

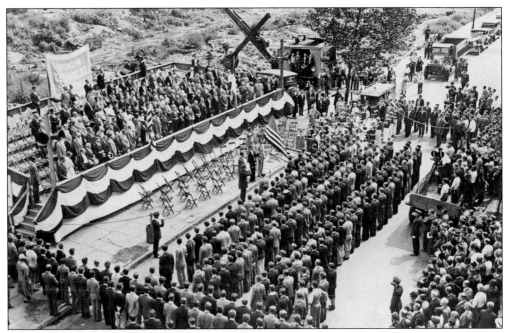

It was a major event when dignitaries and rows of students assembled in 1930 to dedicate the Brooklyn Technical High School in Fort Greene Place. (Brooklyn Tech Alumni Association.)

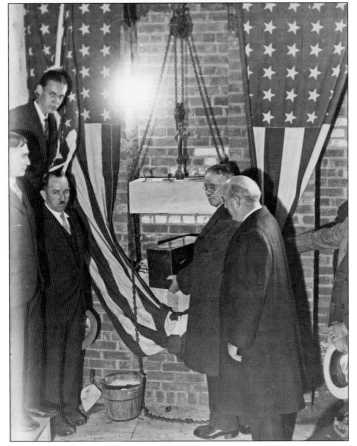

When the cornerstone was laid for Brooklyn Technical High School in 1930, it was an auspicious start for a premier institution that would produce two Nobel Prize winners, as well as famed engineers and astronauts. (Brooklyn Tech Alumni Association.)

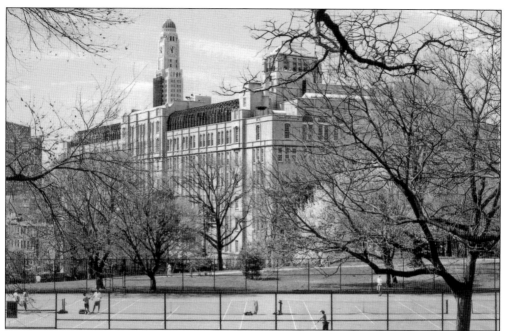

Following an earlier high school for boys, located on the Flatbush Avenue Extension, the mammoth, current Brooklyn Technical High School in Fort Greene Place arose in 1930. It is one of the premier high schools in New York, notable for engineering, science, math, bio-med, and aerospace. (Author's photograph.)

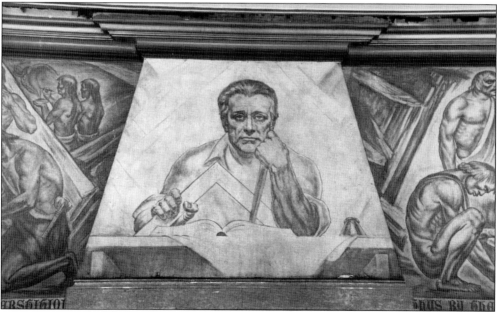

A Russian émigré, Maxwell Starr (1909–1978), won a Depression-era Works Progress Administration (WPA) commission to paint a tableau of murals at Brooklyn Technical High School. He pored over scientific history and worked for four years to complete these paintings in Venetian red tones, depicting the advent of man from the Stone Age to the 20th century. Subjects include Euclid, Archimedes, Pasteur, and Einstein. (Phoebe Ferguson photograph.)

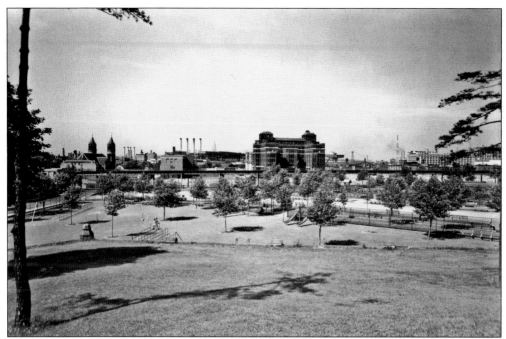

From the Martyrs Monument height in the park, this view north reveals a vista before the Fort Greene Houses were built. The dark ribbon across the center is the Myrtle Avenue elevated line, with St. Edward's twin spires at left and the Cumberland Hospital in the center. (MTA Bridges and Tunnels Special Archive.)

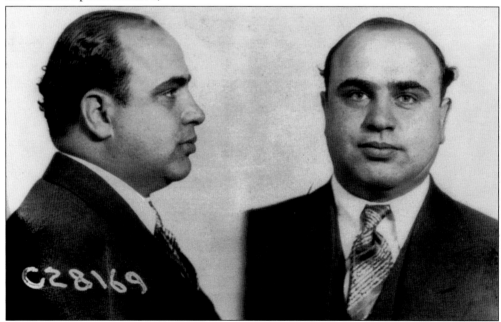

Alphonsus (Al) Capone was born in 1899 at 95 Navy Street, where the Ingersoll Houses are now. At 14, Capone founded the Brooklyn Rippers gang, and in Chicago in 1929 on St. Valentine's Day, he massacred all his enemies. Yet he went to Alcatraz for tax evasion, not murder. (Chicago History Museum.)

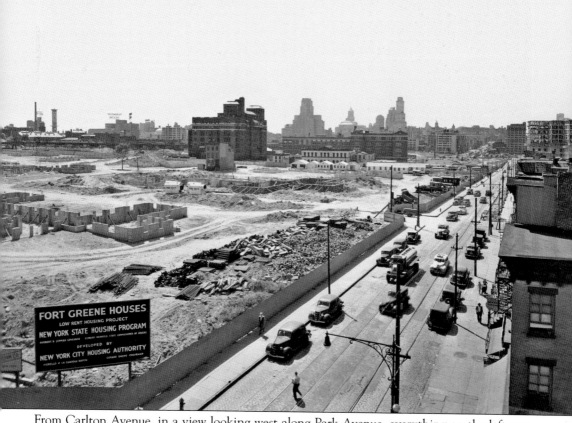

From Carlton Avenue, in a view looking west along Park Avenue, everything on the left was razed for the Fort Greene Houses "low rent housing project" in 1941. Parks commissioner Robert Moses was the "czar" of this planning. The former Cumberland Hospital and downtown Brooklyn are at center. Foundations for the Whitman Houses are already in place in the left foreground. (MTA Bridges and Tunnels Special Archive.)

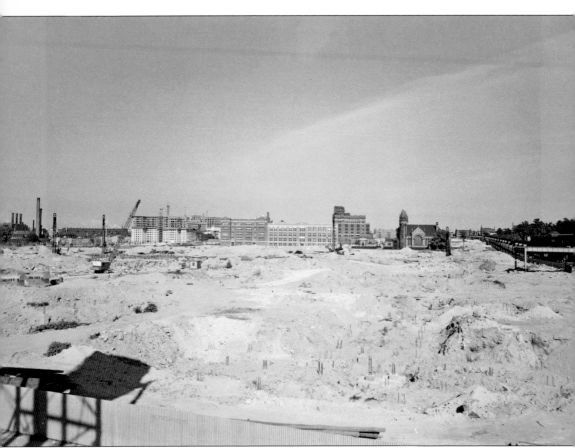

East from Navy Street, with Myrtle Avenue and its elevated tracks on the right, 32 acres were cleared for the Fort Greene Houses. Ely Kahn and Wallace Harrison designed some units, while Rosario Candela did others. Candela designed the posh 740 Park Avenue apartments in Manhattan, home of the Rockefellers and Jacqueline Beauvier, but he needed work during the Depression. (MTA Bridges and Tunnels Special Archive.)

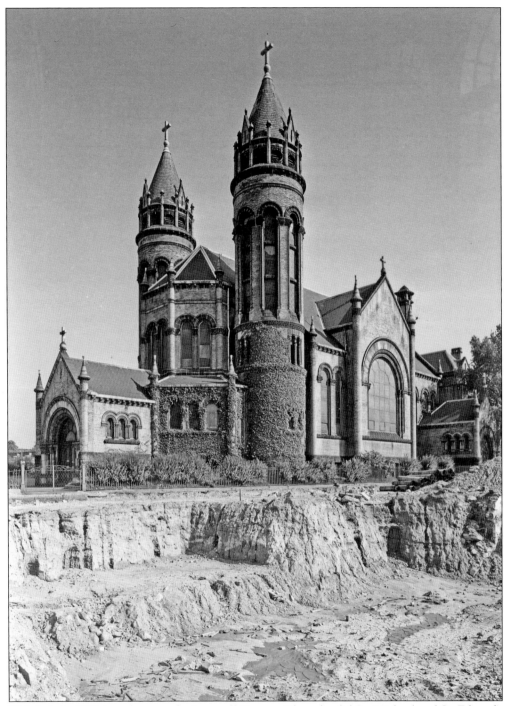

This hole in 1941 later became the Ingersoll Houses. The splendid St. Michael and St. Edward's Roman Catholic Church in Richardsonian Romanesque style is pictured at the rear, with Norman-like spires. John Deary designed the church. Bishop John Loughlin laid its cornerstone in 1891 for a church principally to serve the then Italian community of Fort Greene. (MTA Bridges and Tunnels Special Archive.)

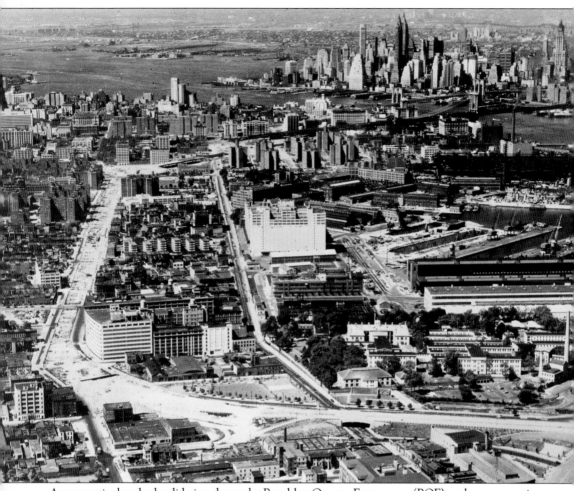

A perspectival and splendid view shows the Brooklyn Queens Expressway (BQE) under construction in 1957. At the bottom, the BQE strips in right to left from Williamsburg and swings west along Park Avenue before jogging south into Brooklyn Heights at the upper left. The large warehouse in the center is now the Free Trade Zone for goods in transit via the Brooklyn Navy Yard. (MTA Bridges and Tunnels Special Archive.)

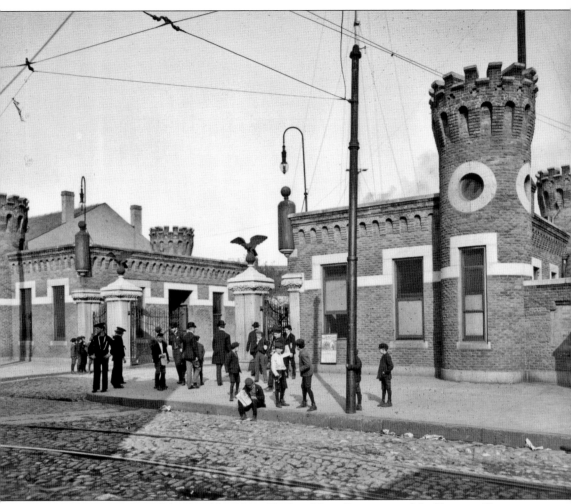

The Sands Street Gate of the Brooklyn Navy Yard, at Navy Street east of the Farragut Houses, dates from 1901. Its crenellated turrets and imperious gatepost eagles were refurbished in 1937, then later shrouded in a ghastly sheath. Plans are being made for another restoration. Originally, John Roebling had planned his Brooklyn Bridge exit to approach the gates, but it was angled off to Tillary Street. (Juniper Gallery.)

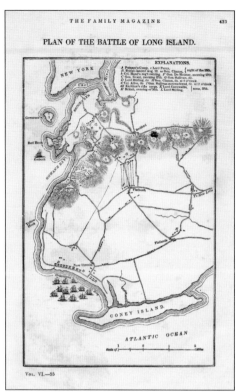

PLAN OF THE BATTLE OF LONG ISLAND.

Defensive entrenchments (here in gray tones) during the War of Independence were dug in an arc roughly from Red Hook on around to Wallabout Bay. In this rough sketch, Fort Greene is approximately at the center of the arc. (Fort Greene Park Conservancy.)

When British troops landed in Brooklyn in 1776, pitched battles were fought with Americans along the harbor leading to Fort Greene. In August, the patriots had to retreat to Manhattan, but their army was saved to fight another day. (Fort Greene Park Conservancy.)

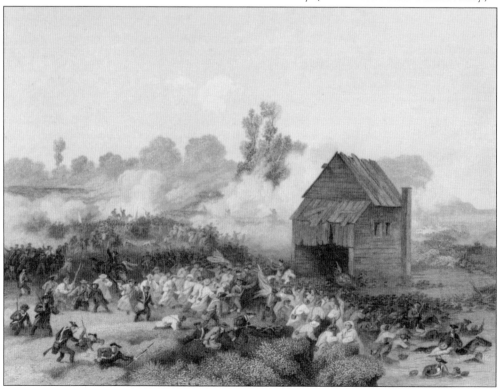

Three

ON WITH THE SHOW

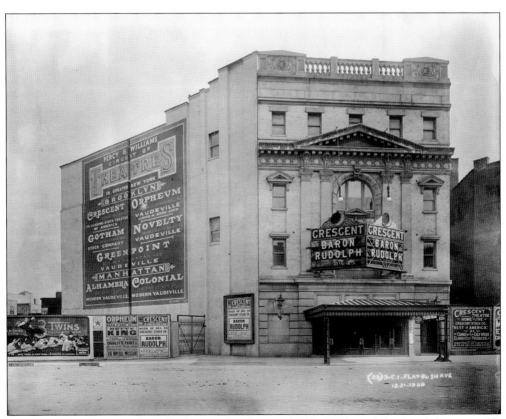

Baron Hieronynimus Karl Friedrich von Munchausen (1720–1797) stuck his hand down a wolf's throat to turn it inside out, and he also met Don Quixote. That is what was told in a skit in 1909 at the Crescent Theatre, on the west side of Flatbush Avenue at Livingston Street, now gone. The play was made into a Baron Rudolph film in 1989. (New York Transit Museum.)

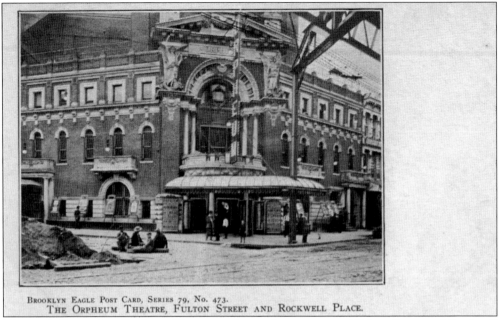

The gaudy Beaux-Arts Orpheum Theatre at the southwest corner of Fulton Street and Rockwell Place was designed by architect Frank Freeman. It was quite different from his Romanesque Revival Eagle Warehouse at Fulton Ferry. The Orpheum, built for vaudeville around the turn of the 20th century, became an RKO (Radio Keith Orpheum) cinema before its demolition in 1953. (Brooklyn Historical Society.)

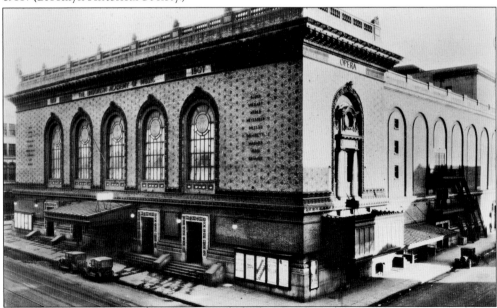

Henry Herts, a graduate of l'Ecole des Beaux-Arts in Paris, teamed up in New York with Hugh Tallant; they were a pair of the foremost theater architects. They designed the Lyceum and New Amsterdam theaters in Manhattan, as well as this 1908 Brooklyn Academy of Music (BAM). Its Italian Renaissance style is replete with a colorful terra-cotta cornice, seen here in 1920. It was replaced in 2007. (BAM.)

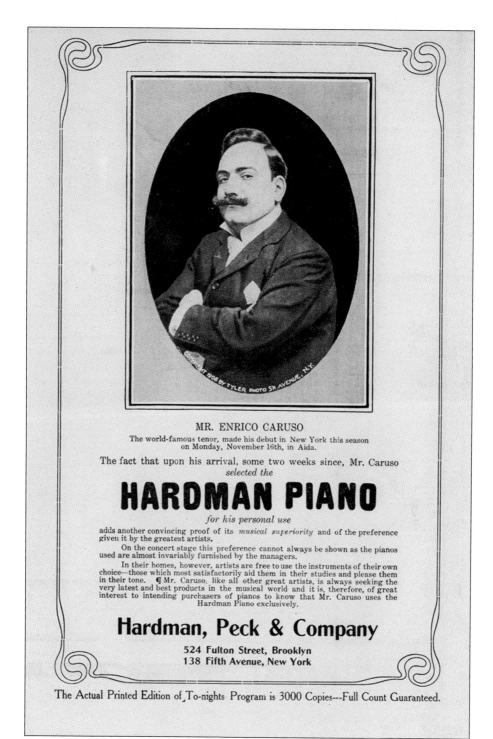
At the opening gala of a new Brooklyn Academy of Music in 1908, Geraldine Farrar and Enrico
Caruso starred in Charles Gounod's *Faust*. Caruso also appeared at the BAM in 1920 in Gaetano
Donizetti's *L'elisir d'amore*, during the first act of which he suffered a throat hemorrhage, ending
the opera. Though he attempted feebly to sing again, he died in Naples a year later. (BAM.)

The opening of the new Brooklyn Academy of Music on Lafayette Avenue was a gala occasion, for it succeeded the loss of the earlier academy on Montague Street that was consumed by fire in 1903. A playbill for *Faust* featured the opening performance. (BAM.)

Among the cavalcade of performers at the BAM in its early years in Fort Greene was the legendary dancer Isadora Duncan. Her lithesome body—in billowy Grecian folds, along with bare feet—became a sensation. Her days, and drinking, in Paris and London brought her more fame, or better, notoriety. A lengthy scarf around her neck ended her life in Nice in 1927, as it got entangled in the spokes of an open-air touring car. (BAM.)

Booker T. Washington's talk at the BAM in 1915 explored the strife that African Americans had overcome through their own diligence. His own spur toward education for young blacks was evidenced at the Tuskegee Institute. (BAM.)

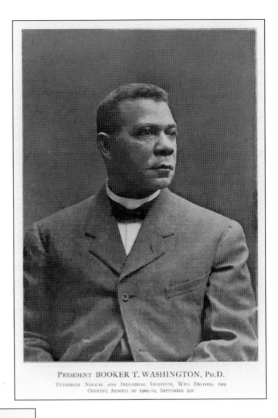

PRESIDENT BOOKER T. WASHINGTON, Ph.D.
Tuskegee Normal and Industrial Institute, Who Delivers the
Opening Address of 1909-10, September 22D

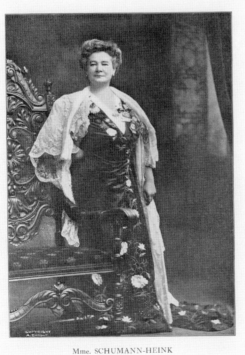

Mme. SCHUMANN-HEINK

By 1909, as a contralto when she sang at the BAM, Tini Rossler, born near Prague, had married a Heink and a Schumann (and later a Rapp), but performed as Erenstine Schumann-Heink. In that same year, by now a busty lady, she originated the role of Clytemnestra in Richard Strauss's *Electra*. Finding herself broke after the 1929 stock crash, she still sang at the Metropolitan Opera in 1931 at age 71. (BAM.)

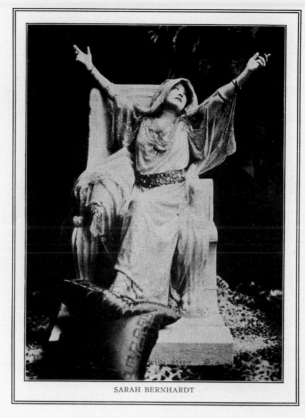

SARAH BERNHARDT

IN REPERTOIRE

SATURDAY AFTERNOON, DECEMBER 30, 2:15 O'CLOCK

Hecuba Rosalie Joan of Arc Camille

SATURDAY EVENING, DECEMBER 30, 8:15 O'CLOCK

Cleopatra La Chance du Mari

Champ d'Honneur L'Holocauste

RESERVED SEAT TICKETS

On sale on and after Wednesday, December 20, at 8:30 A.M.

To Members (with Coupons)...75c., $1.25, $1.75
To Persons not Members..$1.00, $1.50, $2.00

Boxes $3.00 and $5.00

INSTITUTE TICKET OFFICES

ACADEMY OF MUSIC...8:30 A.M. until 9:00 P.M.
ABRAHAM & STRAUS (Subway Entrance, East Building, Fulton St.).....................9:00 A.M. until 6:00 P.M.
FREDERICK LOESER & CO. (Piano Rooms, Fourth Floor)9:00 A.M. until 6:00 P.M.

"The Divine Sarah" was born Sara Bernardt in France, but she added an "h" to both names and was hinted to be bisexual—one reason, perhaps, why Alexandre Dumas called her a "notorious liar." Celebrated as an actress, Sarah Bernhardt lost a leg in 1915 yet carried on, performing at the BAM in 1917 from a repertory of her famous roles such as Joan of Arc, Cleopatra, and Camille. (BAM.)

Parting waves is what athlete, lawyer, and basso profundo Paul Robeson did for people such as Sydney Poitier, Harry Belafonte, and Laurence Fishburne. Robeson's singing, as at the BAM in 1930, became epochal. He was also the very first black actor to play Othello on Broadway. During the McCarthy era in the 1960s, and after, the CIA hounded him for his world-peace activism until his death in 1976. (BAM.)

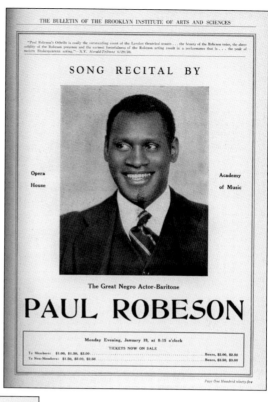

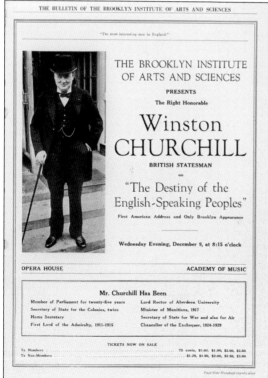

Already well-known in the American realm, Winston Churchill expounded at the BAM in 1932 about "The Destiny of the English-Speaking Peoples." He appeared on behalf of the Institute of Arts and Sciences, at the time housed at the BAM. (BAM.)

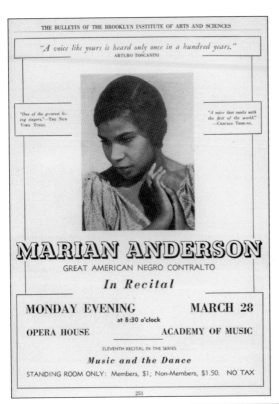

Pivotal in the march of African Americans toward human rights was Marian Anderson, a contralto of "intrinsic beauty." Only once did she appear in opera, preferring recitals or concerts. When she sang at the BAM in 1938, the hall announced "standing room only." That was just a year before Eleanor Roosevelt asked her to sing at the Lincoln Memorial after the Daughters of the American Revolution (DAR) refused her entry to Constitution Hall. (BAM.)

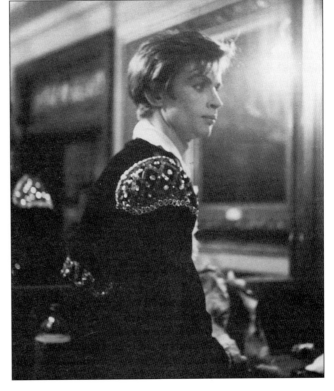

Siberian-born Rudolf Nureyev would enter the Kirov Ballet School in Leningrad (St. Petersburg), becoming a Soviet standout. Allowed to dance in Paris, he was hugely acclaimed, but the KGB, the national security agency of the Soviet Union, wanted him back in Russia. Defecting in 1961, he first danced in America in 1962 at the BAM in *Don Quixote*. Later he and Margot Fonteyn thrilled audiences until 1988, he at 50 and she at 69. (Arthur Todd photograph.)

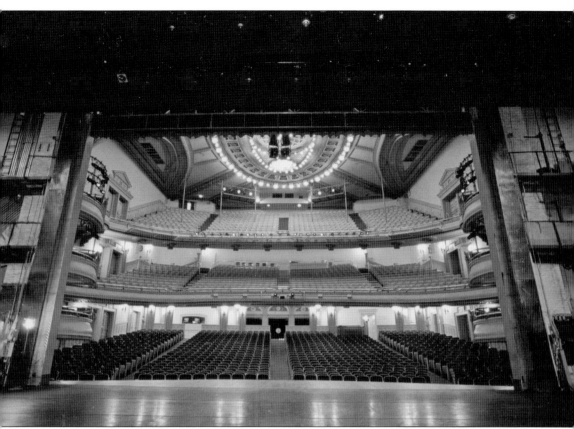

As a showplace, Fort Greene's 1908 Brooklyn Academy of Music's Howard Gilman Opera House has a brilliance all its own. Its stage mechanicals can produce settings from an Olympic-size fish tank to a Tarzan trapeze jungle. Theater like this always brings "Bravi!" from an audience capacity of 2,200 people, as do the Brooklyn Philharmonic performances here. (BAM.)

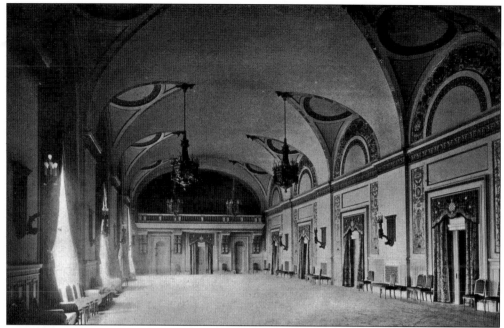

When first opened, the BAM's upper ballroom dazzled as if a royal *salle* in Europe. Great brocaded pelmets crowned the doorways off the theater's balcony. Many galas for stage stars and singers were held here. It languished, however, as did Fort Greene by 1958, and the ballroom was chopped into classrooms and offices for a boys' school. (BAM.)

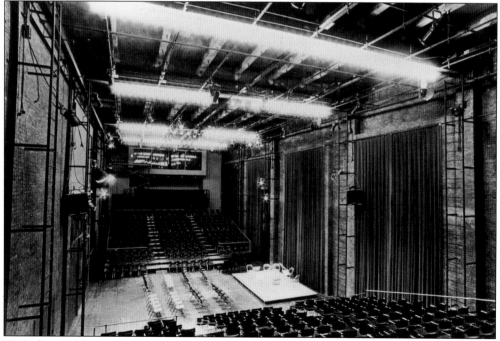

With the need for a more intimate theater than the BAM main hall, the old upper ballroom was stripped down in 1973. Here an open-stage approach took place in what was called the Lepercq Space. (BAM.)

In 1997, the old BAM ballroom was stripped bare again after being a black box theater. It was then fitted out with expansive overhead trusses and sparkling lights to become the BAMcafé for dinners and popular live music events. (BAM.)

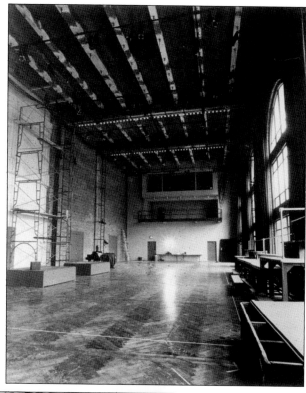

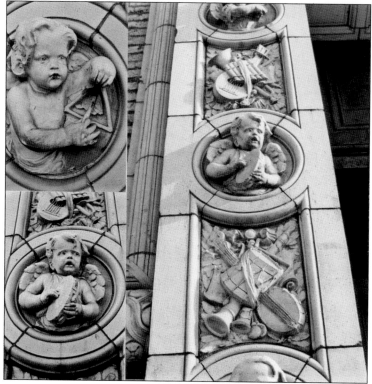

Whether funny or ferocious, architectural icons have guarded their structures for aeons. Fort Greene is richly alive with such motifs, many from the Atlantic Terra Cotta Company, which has ornamented some 40 percent of all buildings in New York. These cherubs are little musicians on the facade of the BAM. Many other icons appear on the way to the train. (Author's photograph.)

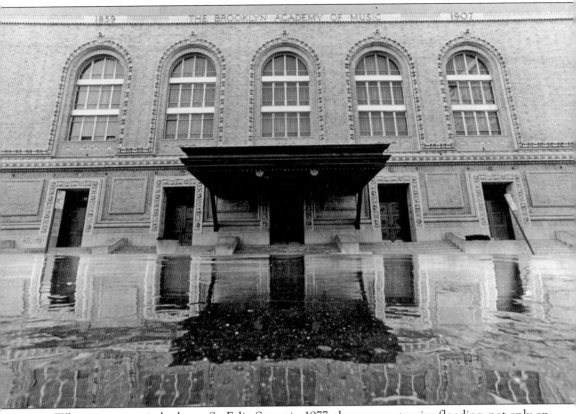

When a water main broke on St. Felix Street in 1977, there was extensive flooding, not only on Lafayette Avenue in front of the BAM, but in the inner theater up to the stage level. A massive restoration was required. (BAM.)

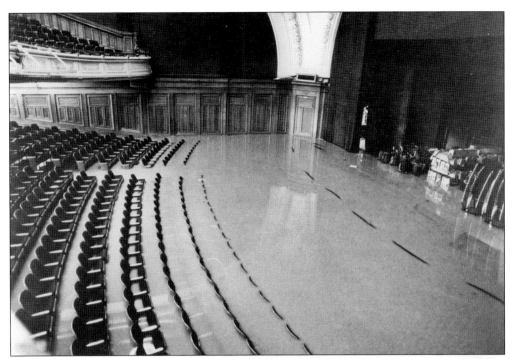

When the BAM Opera House was flooded by a water main break in 1977, most of the seats were ruined and had to be replaced. Moreover, costly renewals were required for the stage's mechanical equipment. (BAM.)

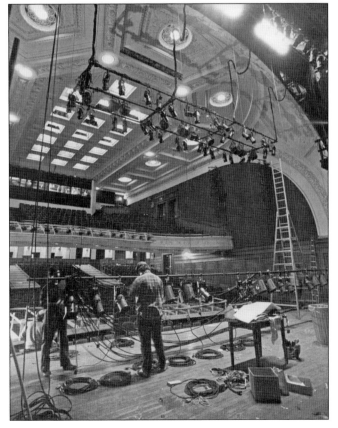

In the east hall of the main BAM Opera House was an auxiliary theater, as seen with these lighting designers. Many stage plays were performed here, and renowned troupes from abroad often expanded the theatrical horizon. In the 1990s, the space was reconfigured into the BAM Rose Cinema, now a popular, multiscreen venue with good popcorn. (BAM.)

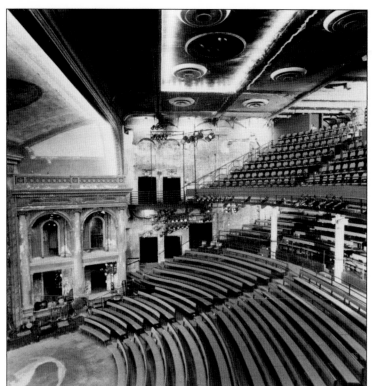

Long after vaudeville and film, the Majestic Theatre on Fulton Street lay dark and derelict. In 1987, the Doris Duke Foundation gave funds to restore it, and they wanted to rename it the BAM Harvey for longtime programming expert Harvey Lichtenstein. That year began the great Next Wave series of annual festivals that included top theater works and DanceAfrica. (BAM.)

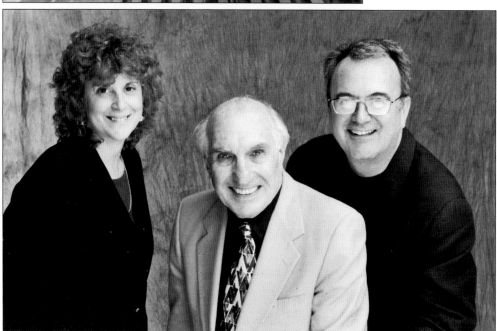

Three titans of the Brooklyn Academy of Music have long overseen the tops in theatrical programming. The Next Wave Festival and DanceAfrica are among the highlights each year. Pictured here are, from left to right, Karen Hopkins, president of BAM; Harvey Lichtenstein, president emeritus; and Joseph Melillo, executive producer. (Timothy Greenfield-Sanders.)

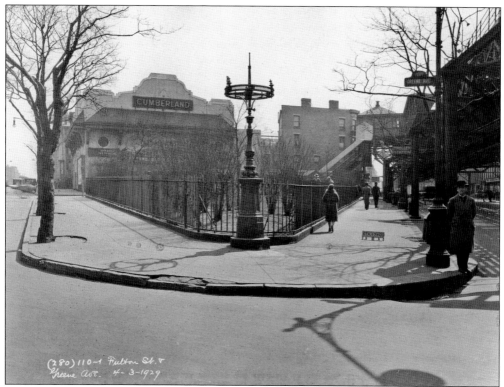

(280) 110-1 Fulton St. &
Greene Ave. 4-3-1929

After descending from the Fulton Street Elevated line at the Cumberland Street stop, people walked left, into the Cumberland cinema, the stair-step building at far left. A delightful gas torchiere stood just before the then small Cuyler Gore Park in 1929, at the apex of Greene Avenue and Fulton Street. (New York Transit Museum.)

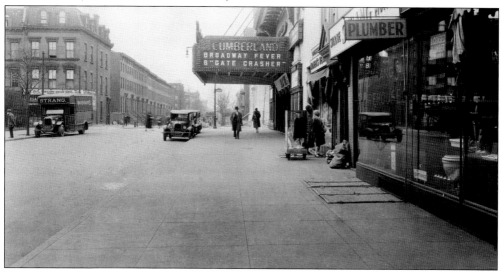

Now playing: *Broadway Fever* at the Cumberland Theatre; this view is looking north between Fulton Street and Greene Avenue. Sally O'Neil starred as a young servant girl trying to hoof herself onto Broadway. The Cumberland, pictured in 1929, later became an A&P supermarket. (New York Transit Museum.)

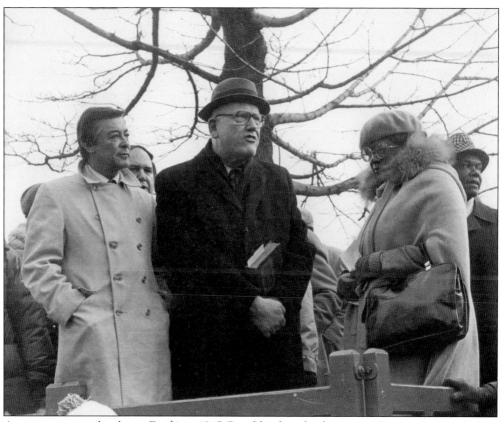

A gore is a triangular shape. For $1 in 1845, Brooklyn bought the gore at Greene Avenue, Fulton Street, and Cumberland Street and later named it Cuyler Gore Park for the then pastor of the Lafayette Avenue Presbyterian Church, Theodore Cuyler. By 1980, when buildings at the east were derelict, the city razed them and broke ground for a larger park. Officiating were then borough president Howard Golden, the late Rev. George Knight of Lafayette Church, and the late Mary Pinkett, city council member. (LAPC.)

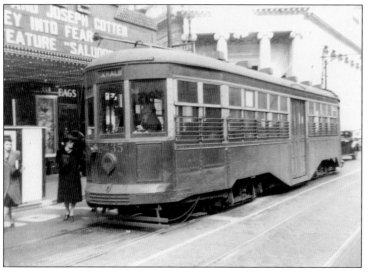

A DeKalb Avenue trolley has descended in 1942 from Fort Greene to a stop in front of the Albee Theatre, where DeKalb Avenue joins Fulton Street. Joseph Cotton and Delores del Rio were starring in *Journey into Fear*. The Dime Savings Bank is at the rear. (New York Transit Museum.)

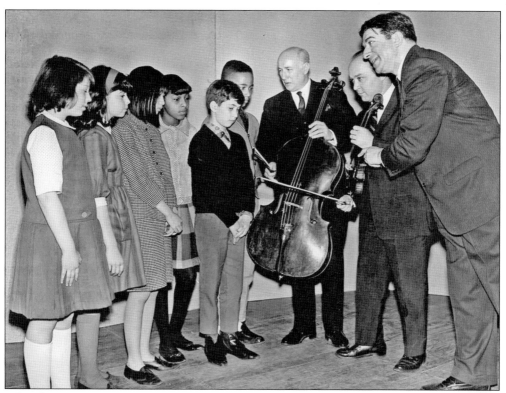

After fleeing the Nazis in 1939, Siegfried Landau trained musically in London and New York. In this city, he taught classical scores as well as cantorial lore. In 1955, he originated the cherished Brooklyn Philharmonic in Fort Greene, and here he also took special care to let school children meet and hear good musicians. Landau and his wife tragically perished in a fire at their Adirondacks home in 2007. (Brooklyn Philharmonic.)

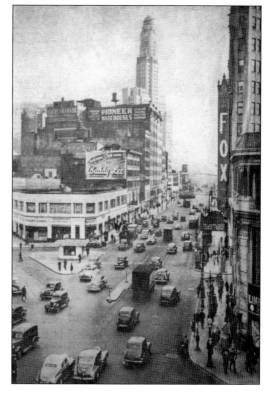

The Fox Theatre and others around Flatbush Avenue and Fulton Street were a cinematic mecca for all Brooklynites. Traffic, busy as always, scooted along Flatbush Avenue from Fulton Street heading toward Fort Greene's epitome of height in 1947, the Williamsburgh Savings Bank. (Brooklyn Historical Society.)

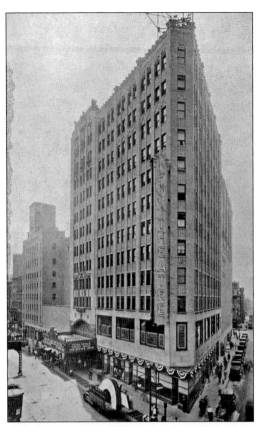

Two years before the 1929 stock market bust, the Fox Theatre Company hired Howard Crane to design this 12-floor office building and cinema at the southwest corner of Flatbush Avenue and Nevins Street. The theater became Murray the K's hot rock-and-roll scene in the 1950s. Con Edison bills kilowatts today from its 1972 building replacement, a black ingot by Skidmore, Owings, and Merrill. (Brooklyn Historical Society.)

Howard Crane designed a number of theaters for Hollywood extravaganzas and set the mood the moment one enters. In this Fox Theatre at Flatbush Avenue and Nevins Street, there was a mixture of styles, including Byzantine and rococo. It was quite a rival for the Brooklyn Paramount at DeKalb and Flatbush Avenues. (Library of Congress.)

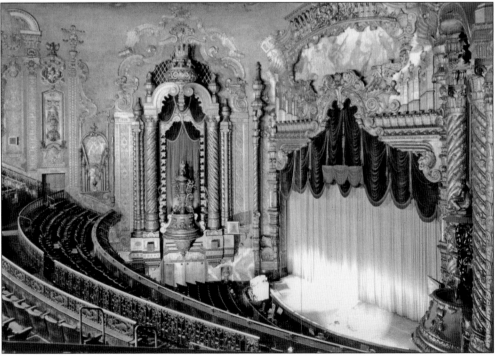

Fantasmagoric is scarcely the word for the Fox Theatre, which some called Byzantine rococo and others said was Siamese baroque. Here is where Murray the K (Kaufman) picked up the rock-and-roll baton from Alan Freed at the Paramount. Murray was among the first to invite black and Latino artists, a nice break for the time. (Library of Congress.)

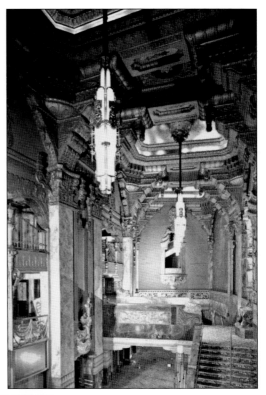

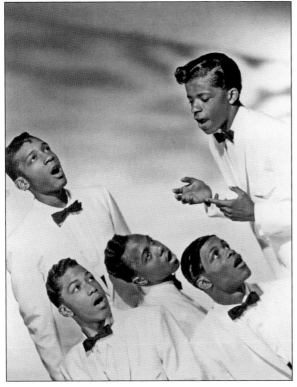

Jerome Anthony Gourdine, top right, grew up in the Fort Greene Houses in the 1940s. He is best known from the Little Anthony and the Imperials famous 1950s song "Tears on My Pillow." Afterward, the Imperials hit Billboard's Top Ten with songs like "Goin' Out of My Head" and "Hurt So Bad." Little Anthony and his group got raves on the *Ed Sullivan Show*. (Photographer Michael Ochs Archives, Getty Images.)

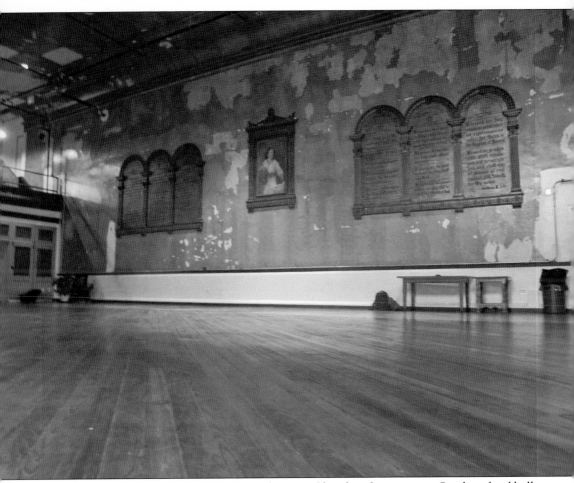

At the rear of the 1863 Lafayette Avenue Presbyterian Church is the cavernous Sunday school hall, long disused. In 2007, the Irondale Theatre Ensemble transformed the space at 85 South Oxford Street into a thrilling, adaptable theater, or sometimes a reception venue. Although Irondale's mechanicals are new, the painting of a young Jesus remains as was. (Irondale Theatre.)

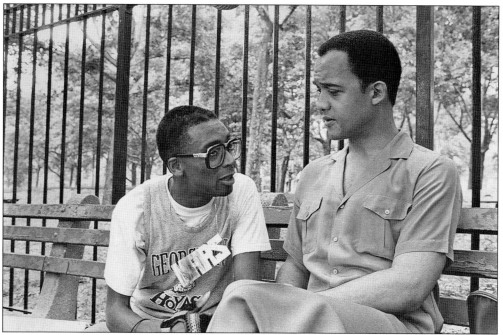

While filming the 1986 hit *She's Gotta Have It*, Shelton (Spike) Lee, at left, sets a scene for Tommy Richmond Hicks. Spike Lee grew up in Fort Greene, and this big breakout film was largely shot here, as was this image in Fort Greene Park. (Spike Lee.)

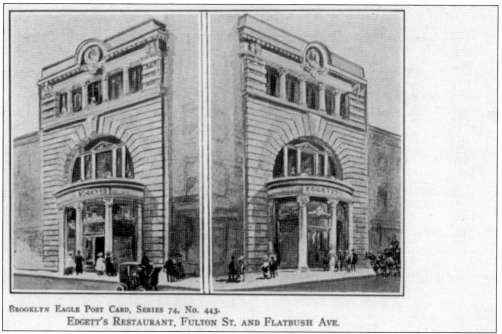

BROOKLYN EAGLE POST CARD, SERIES 74, No. 443.
EDGETT'S RESTAURANT, FULTON ST. AND FLATBUSH AVE.

Edgett's Restaurant was such a good eatery that an Eagle postcard showed it two ways. The restaurant was located on the southeast corner of Fulton Street at Flatbush Avenue. It was opulent at a time when some 40 theaters operated in Fort Greene and downtown Brooklyn. A fire on Edgett's third floor caused a stampede in 1905, but no one was injured. (Brooklyn Historical Society.)

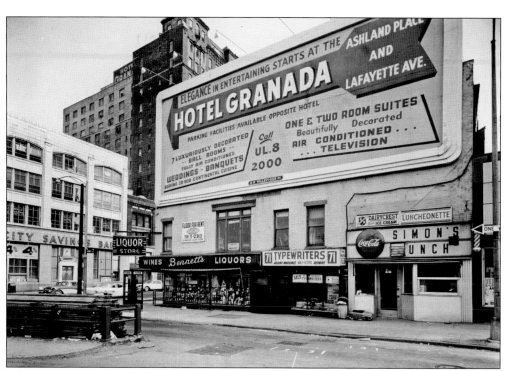

"Elegance in Entertaining" was promised at the Granada Hotel, still the epitome of swank in this 1962 image. The sign at the southwest corner of Nevins Street and Flatbush Avenue points toward the Granada, seen overhead at the top. (New York Transit Museum.)

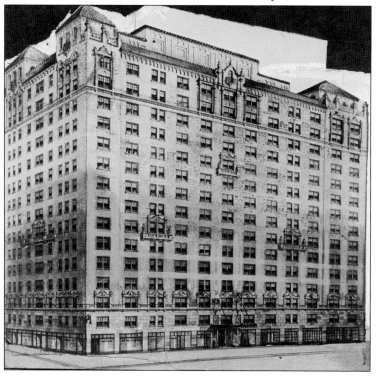

Sixteen stories high, at the northwest corner of Ashland Place and Lafayette Avenue, the 1927 Granada Hotel was a posh spot for ladies in hats and white gloves taking tea. Balls were held in its Forsythia Room, and teams playing the Brooklyn Dodgers most likely stayed there. By the 1970s, it was best known for crack and prostitution and then became the Brooklyn Arms, a welfare hotel, before its 1994 demolition. (Brooklyn Public Library.)

Four

LIFE AS LIVED

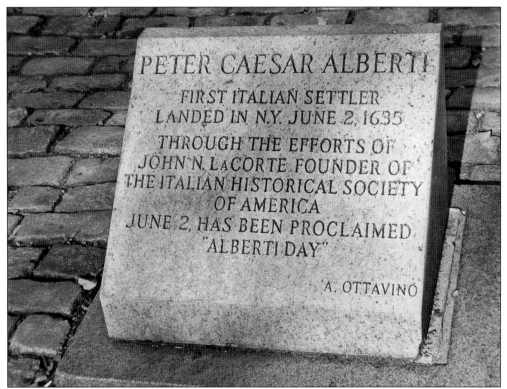

Scion of a wealthy Venetian family, Peter Caesar Alberti arrived in New Amsterdam in 1635, the first Italian here. Within four years, he bought land for a tobacco plantation from Peter Montfort at Wallabout Bay, then added still more land in Fort Greene. In 1655, fate overtook him when he and his wife, Judith Manje (a Walloon), were hatcheted in an Indian raid. (Battery Park Conservancy.)

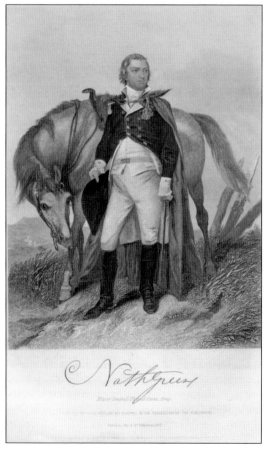

Pictured faintly, the extinct Ryerson house typifies the 18th-century houses once in Fort Greene, such as the Provoost house on Cumberland Street near the Navy Yard. Ryerson's home, with a gambrel roof on Adelphi Street, south of Flushing Avenue, was on Jose DeBevoise's farm in 1740. It remained in the DeBevoise family until John Ryerson bought it in 1805. (Brooklyn Historical Society.)

This military leader had seven first names and was probably happy just to be called the Marquis de Lafayette. The brave French strategist aided General Washington during the War of Independence, enduring wounds at the Battle of Brandywine. On his later return to Fort Greene in 1821, he received the plaudits of a grateful American people. (Fort Greene Park Conservancy.)

"THE ABBEY" IN 1835—FULTON AVENUE, NEAR JUNCTION OF HUDSON AVENUE.

The Abbey was never intended for Cistercian monks vowing silence. Rather, 19th-century historian Henry Stiles tells that the Abbey, seen in 1835 at the junction of Hudson Avenue and Fulton Street, was a "liquor saloon." Samuel Van Bueren lived there and ran the public house on an earthwork line that was used by Americans for defense during the War of Independence. (Brooklyn Historical Society.)

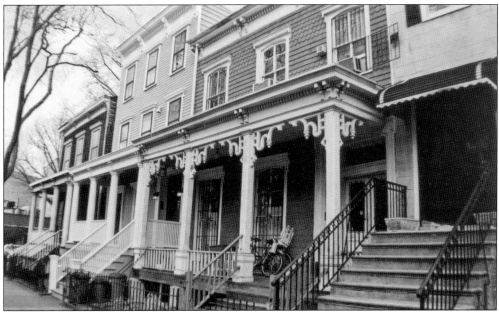

Fort Greene's Adelphi Street got its moniker from Robert Adams's 1768 terraced homes along the north banks of the Thames in London. Here this winsome trio of Greek Revival, clapboard houses with Italianate cornices is among the earliest in Fort Greene. The two on the left date from around 1848. Doric columns and jigsawed spandrels add zest, rather like a splash of lemon on sole. (Author's photograph.)

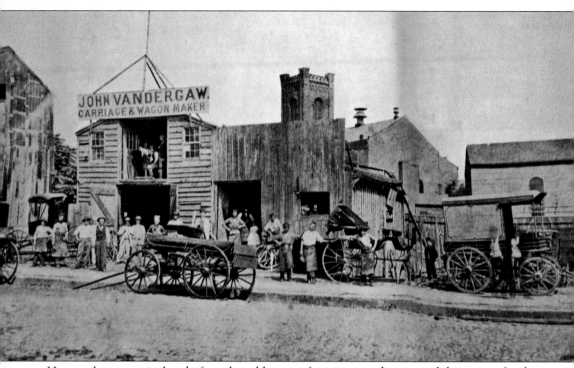

Horses, the unrequited and often abused heroes of carriages and wagons, did not pose for this picture when everyone had to "freeze" for the slow shutter speed. In 1860, Vandergaw was at the junction of Fulton Street and DeKalb Avenue, probably where the Dime Savings Bank now stands. The buildings in background are unidentified. (Roger Whitehouse Collection.)

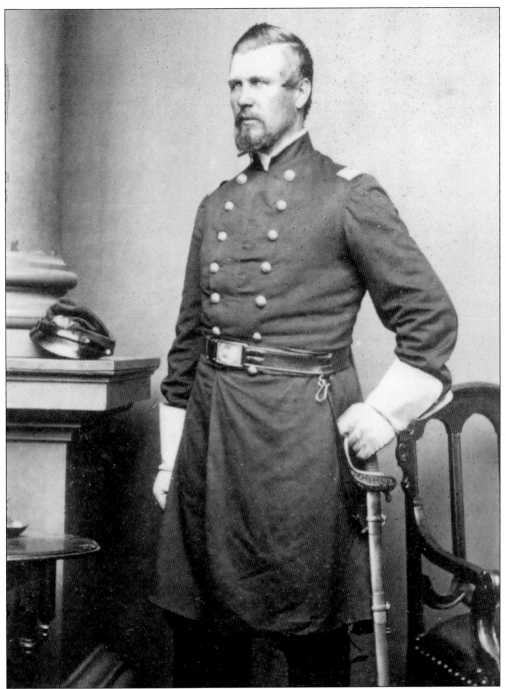

Edward Brush Fowler of Fort Greene was a lieutenant colonel of Brooklyn's New York State 14th Regiment when called to war in 1863. President Lincoln allowed the soldiers to retain their blue tunics and red britches. They fought so fiercely at Gettysburg that Southerners called them the "red legged devils." Promoted to general, Fowler's statue by Henry Baerer was erected in Fort Greene Park in 1902. (MA Commandery Military Order and U.S. Army Military History Institution.)

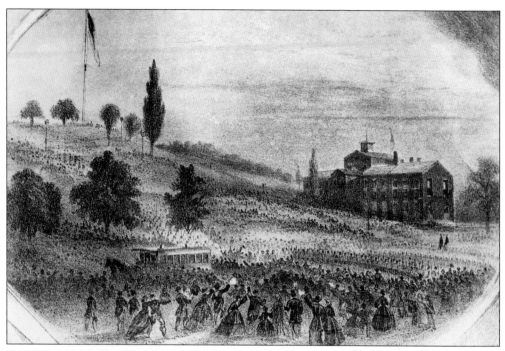

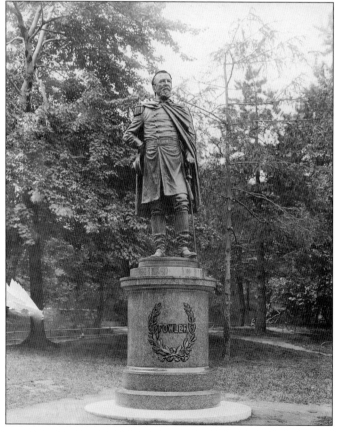

Clad in their blue tunics and red britches, the New York State 14th Regiment ventured away from Fort Greene Park to Fulton Ferry for a ride into the Civil War. Townspeople flocked to wave goodbye to the boys. They sang "The Girl I Left Behind Me" as they parted. (Brooklyn Historical Society.)

Gen. Edward B. Fowler, leader of the New York State 14th Regiment that was primarily from Fort Greene, was still so highly regarded 40 years after the Civil War that a statue of him was erected in Fort Greene Park in 1902. It was created by Henry Baerer. Toppled and damaged, it lay in storage until reerected at Fulton Street and Lafayette Avenue in 1977. (Brooklyn Public Library.)

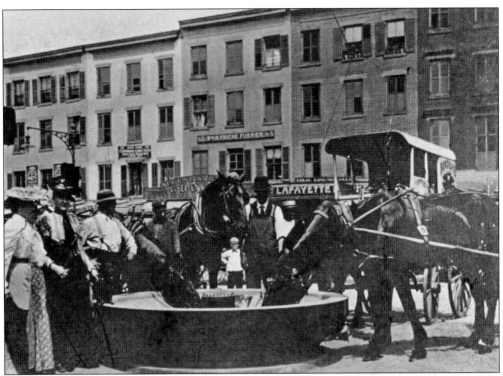

Among the reincarnations at the gore of Fulton Street, Lafayette Avenue, and South Elliott Place was a watering trough that would be doomed after Model T Fords arrived. (Brooklyn Historical Society.)

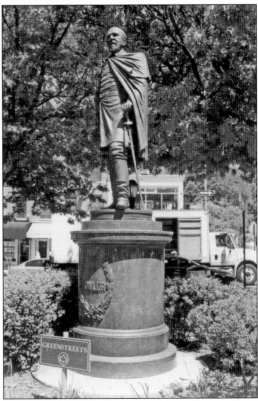

In the 1950s, bronze scrap thieves toppled this 1902 statue of Civil War hero Gen. Edward Brush Fowler—sculpted by Henry Baerer—from its original site in Fort Greene Park. But their stolen truck got stuck in the mud, so the general, his wrist broken, lay in the parks department storage until 1977 when he was reerected at Fowler Square, at the apex of Lafayette Avenue and Fulton Street. His wrist, sword, and patina were refreshed in 1996. (Author's photograph.)

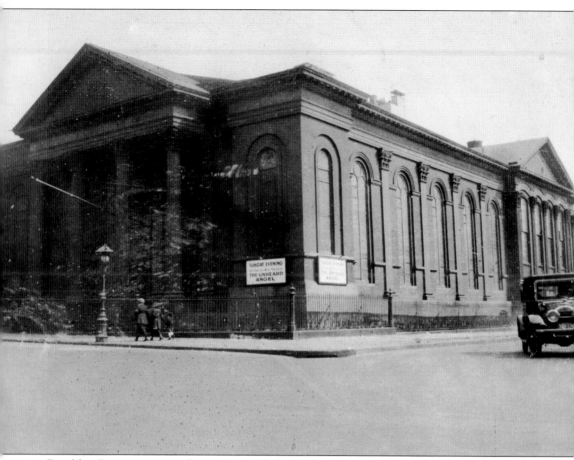

Brooklyn Baptists organized in a store on Atlantic Avenue near Nevins Street in 1854. By 1860, they dedicated this sumptuous Greco-Roman wonder as the Hanson Place Baptist Church, at the corner of South Portland Avenue. George Penchard designed it. With its parishioners dwindling by 1963, Baptists sold the church to a thriving Seventh-day Adventist congregation. The eye-socking, historic building is now landmarked in its own right. (Brooklyn Historical Society.)

A widely revered Protestant song is "Shall We Gather By the River," written by the Reverend Robert Lowry (1826–1899). He was a longtime pastor at the Hanson Place Baptist Church, designed by George Penchard in 1860 and located at Hanson Place and South Portland Avenue. The exciting Greek Revival edifice, now landmarked, later became the Hanson Place Seventh-day Adventist Church. (Stephen Ross.)

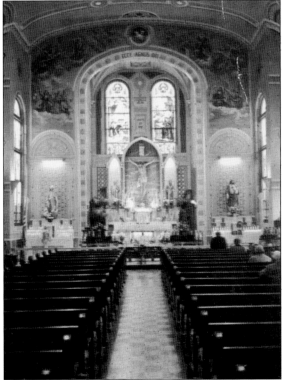

Ecumenical, to say the least, this was first the Church of the Redeemer (Protestant) before becoming a synagogue as Temple Israel in 1878. In 1890, it became the Roman Catholic St. Casimir's Church. Pictured is St. Casimir's altar, where many Polish people genuflected. By the 1990s, it became the Paul Robeson Theatre at 54 Greene Avenue. (Diocese of Brooklyn Archives.)

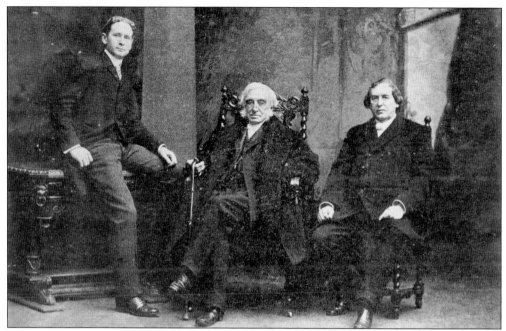

When the Lafayette Avenue Presbyterian Church (LAPC) was finished in 1863, it was first called the Park Presbyterian Church. The name was changed within a decade. Pictured here are the church's three initial pastors: the founder is pictured in the center, Theodore Ledyard Cuyler; second pastor at left, Cleland Boyd McAfee; and third was David Gregg, on the right. (LAPC.)

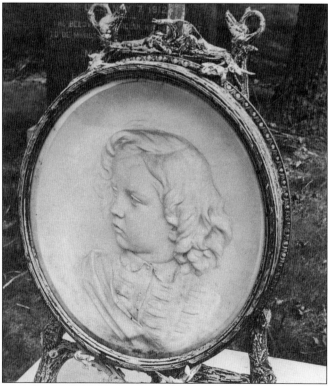

Little George Cuyler, son of Annie and Rev. Theodore Ledyard Cuyler of the Lafayette Avenue Presbyterian Church, was only five years old when scarlet fever "closed his lovely life" in 1868. The family had this cameo of sweet gentility placed at his grave in Green-Wood Cemetery. (Brooklyn Historical Society.)

Military service men and a lone woman (a nurse), all from the Lafayette Avenue Presbyterian Church, were proudly hailed in 1918 by the newspaper, the *World*. (LAPC.)

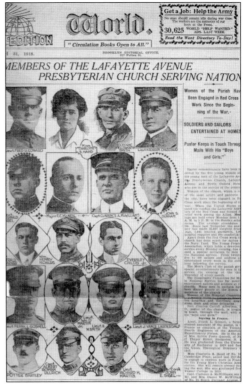

African American men were not allowed to use the YMCA in its early years. Julius Rosenwald, a thoughtful Jewish man, president of Sears, believed, "Treat people fairly . . . and their response will be fair." In 1910, he gave funds for 25 YMCAs for African Americans in 23 cities, one of which was this building on Carlton Avenue between Greene Avenue and Fulton Street. It is now a nursing home. (Author's photograph.)

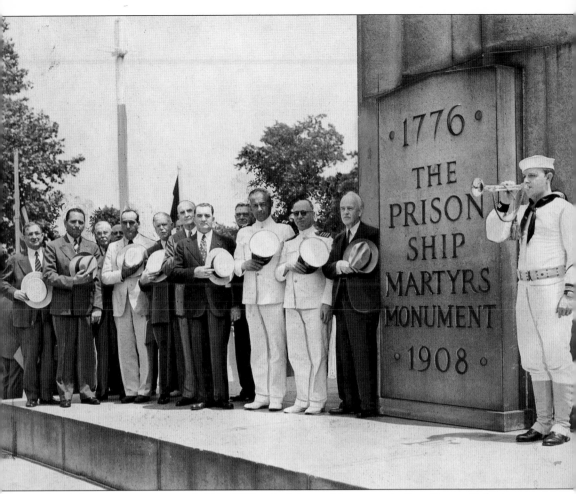

A rededication ceremony was held in 1937 at the Martyrs Monument in Fort Greene Park. Among the attendees were, third from left in a white suit, Parks commissioner Robert Moses (often called the "czar"), and immediately left of the memorial tablet, the then Brooklyn borough president Raymond V. Ingersoll, for whom the housing development is named. (Brooklyn Public Library.)

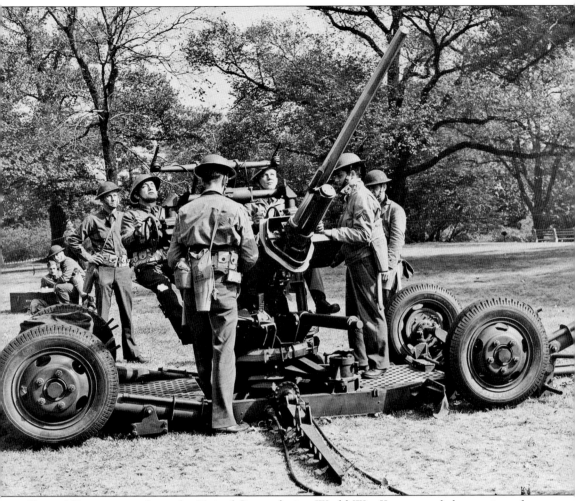

Fear of German attack on the United States during World War II prompted the posting of a 62nd Coast Guard Artillery squad in Brooklyn. They came from Fort Tilden out by Breezy Point and took up one of their positions in Fort Greene Park. (Brooklyn Public Library.)

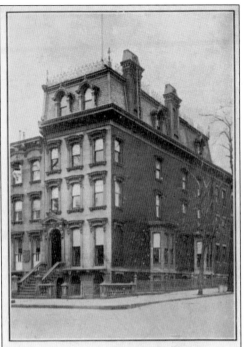

Haughty as "*une grande dame*," the University Club long reigned over the southwest corner of South Elliott Place at DeKalb Avenue, but it was humiliated by demolition in 1930 for Brooklyn Tech. The club's French Second Empire style, with a mansarded roof, expressed the newfound affluence from the 1860s for a brownstone epoch. Much of the stone itself came from the Connecticut River Valley. (Brooklyn Public Library.)

Beneath and between its twin gables with their Italianate cornice, the 1883 Knights of Columbus Hall on South Portland Avenue flaunts a classic order with cartouches and swags, all centering a Palladian window. J. A. Corneal designed the hall that more recently became a church and then fell derelict. It is now David Salle's art studio. (Author's photograph.)

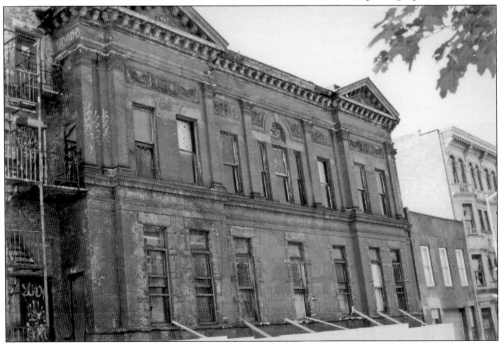

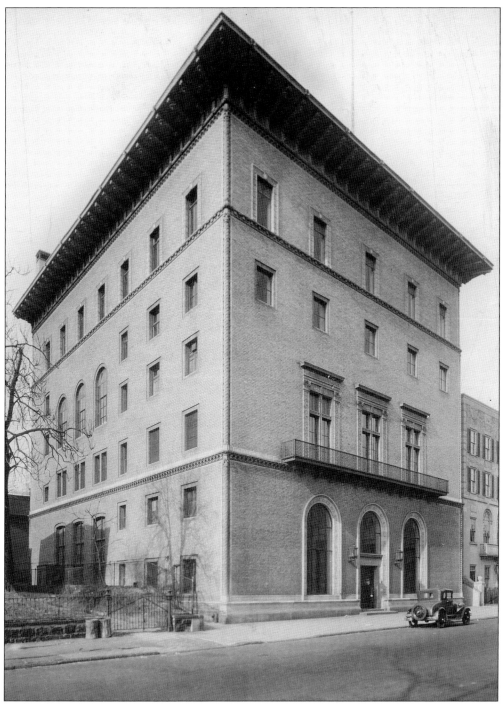

Fraternal organizations once prevailed in Fort Greene, such as Masons and Knights of Columbus. A large structure was also built by Lodge 22, Benevolent Protective Order of Elks, on South Oxford Street between Hanson Place and Atlantic Avenue. Designed in 1913 by H. Van Buren Magonigle, its Italian Renaissance facade had lively terra-cotta embellishments. By 1955, however, its decoration was deflowered for a nursing home. (Brooklyn Public Library.)

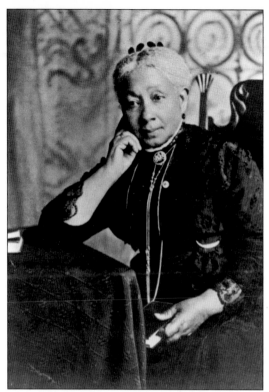

Susan Smith McKinney, M.D., not only looked graciously impressive, she raised sand as the first African American woman to practice medicine in New York state. In 1870, she graduated as valedictorian from her medical college. She went on, as a mother of two, to practice from her home and perform surgery at 205 DeKalb Avenue. (Brooklyn Historical Society.)

From Fulton Street, this view looks north along Clermont Avenue in 1929 toward the Masonic Temple at the far center. The spire of the Anglican Church of the Messiah and Incarnation, perhaps designed by James H. Giles, was begun by Presbyterians in 1863 at 80 Greene Avenue, the southeast corner of Clermont Avenue. They soon sold it to the Episcopalians. A five-alarm fire ravaged it in 1969. (New York Transit Museum.)

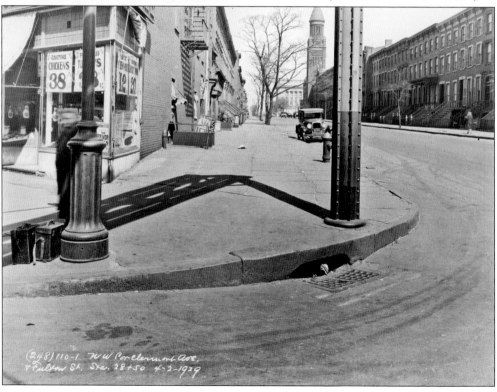

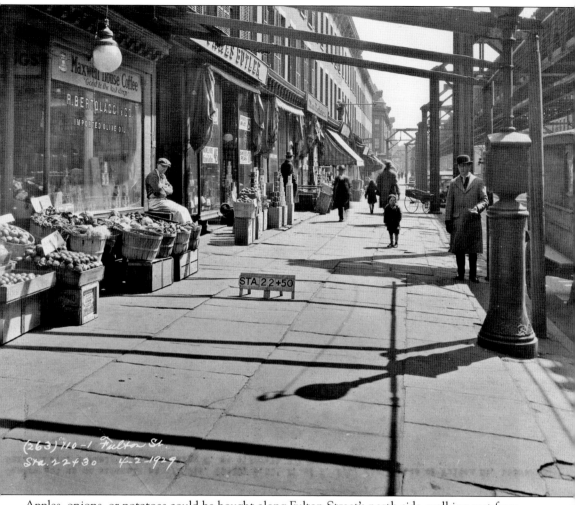

Apples, onions, or potatoes could be bought along Fulton Street's north side, walking east from Carlton Avenue to Adelphi Street in 1929. The clatter of the elevated line and the trolley could be heard at the right. (New York Transit Museum.)

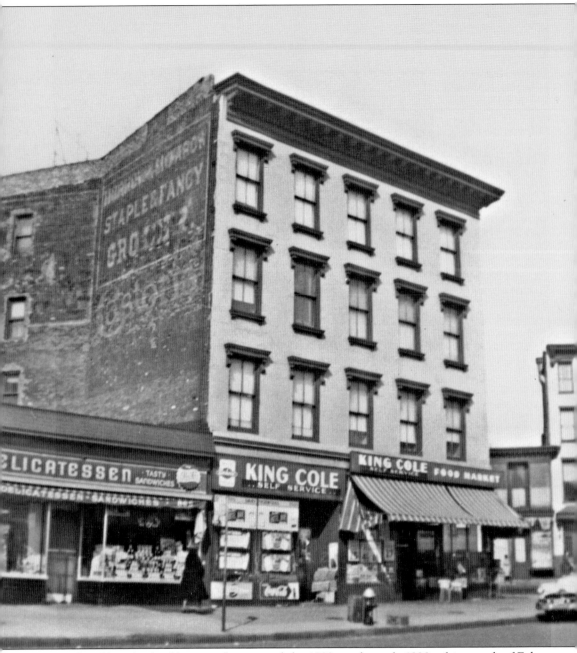

Replaced by subsidized housing flats around the 1980s to the early 1990s, this stretch of Fulton Street, the north side up to Clermont Avenue on the right, was home to King Cole Food Market in 1960. The sidewall sign at the top left says, "Staples and Fancy Groceries." (Brooklyn Historical Society.)

Long before air-conditioning, front porches were basic assets during long, hot summers. Although one porch was closed in by 1958, this was the way Carlton Avenue looked on the east side between Fulton Street and Atlantic Avenue. In 1974, the New York City Housing Authority (NYCHA) built a 300-unit complex on the site. (Brooklyn Historical Society.)

Already chopped of their original cornices by 1958, the two Second Empire storefronts on the right of the north side of Greene Avenue, close to Cumberland Street, evoke the dire need for historic preservation not achieved in Fort Greene until 20 years later. Two peak-roofed homes on the left, built in 1860 by Nicholas Rhodes, once had parlor floors before being "shoplifted." (Brooklyn Historical Society.)

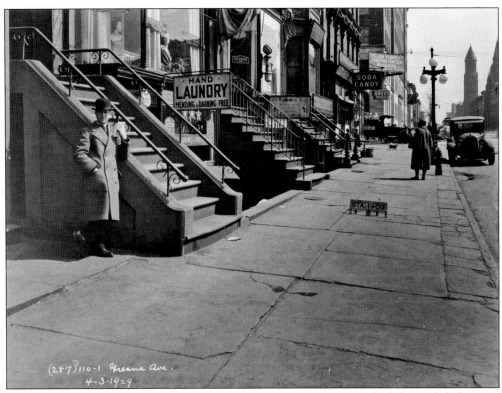

(287)110-1 Greene Ave.
4-3-1929

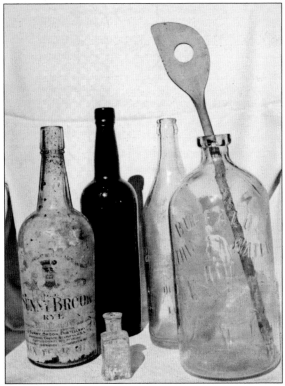

The man on the left stands below the Gothic-style shop houses located on the north side of Greene Avenue, east of South Oxford Street toward Cumberland Street. The newly completed 1929 Brooklyn Eye and Ear Hospital (now the Mugavero Home) is the bulky building on Cumberland Street. St. Casimir's is the first spire on the right, followed by that of the Church of the Messiah and Incarnation. (New York Transit Museum.)

Arrival of water mains, sewers, and flush toilets in the 1880s created a new use of outdoor privy pots as spots for trash. All these bottles are four score or more years old. Sunny Brook Rye at left, from Prohibition days, says it is 50 percent alcohol by volume—"For medicinal purposes." But as they said: "First ya swaller, then ya holler." (Author's photograph.)

This view is from the corner of Cumberland Street at Fulton Street going down the hill to the west. The originally configured Cuyler Gore Park is on the right in this 1960 image. Lots of litter and broken pavement posed a grim reminder that the city's coffers were by then a colander. (New York Transit Museum.)

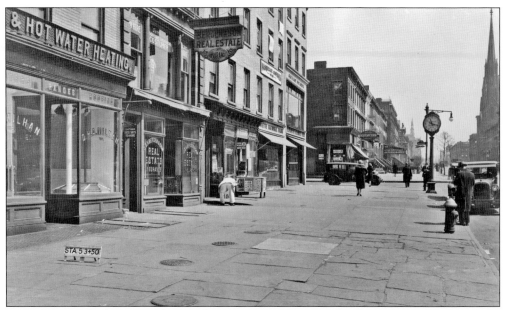

From this view looking east along Lafayette Avenue near South Elliott Place, the spire of the Lafayette Avenue Presbyterian Church can still be seen. Since this photograph was taken in 1929, little more than shop signage has changed. (New York Transit Museum.)

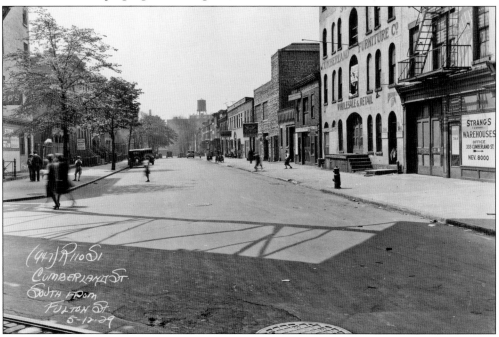

Warehouses and former stables lined Cumberland Street from Fulton Street, pictured in the foreground, south to Atlantic Avenue in 1929. After their razing during the 1960s and 1970s came lost dreams of an Atlantic Terminal Urban Renewal Area (ATURA), a Brooklyn Dodgers Stadium, Baruch College, and Rose Associates' twin office towers. All flunked. Finally, in the late 1990s, the New York City Housing Partnership began rows of modest, low-rise houses. (New York Transit Museum.)

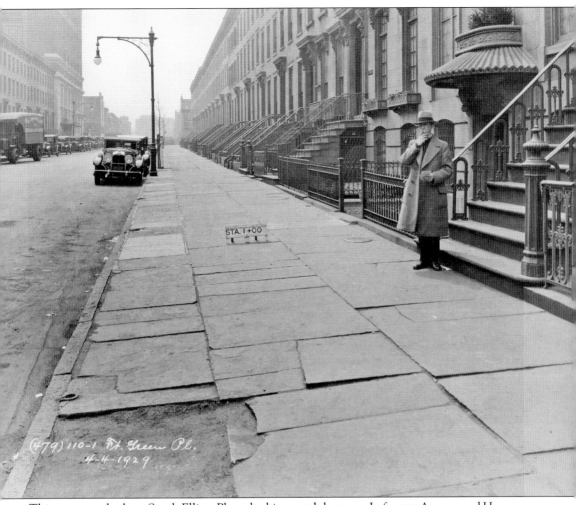

This man stands along South Elliott Place, looking south between Lafayette Avenue and Hanson Place. Though scant of trees in this 1929 scene, the scallop-shelled entryway and other houses are virtually unchanged. Perchance it is why many current Brooklyn residents welcome the ability to renew themselves within the umbilical folds of Fort Greene. (New York Transit Museum.)

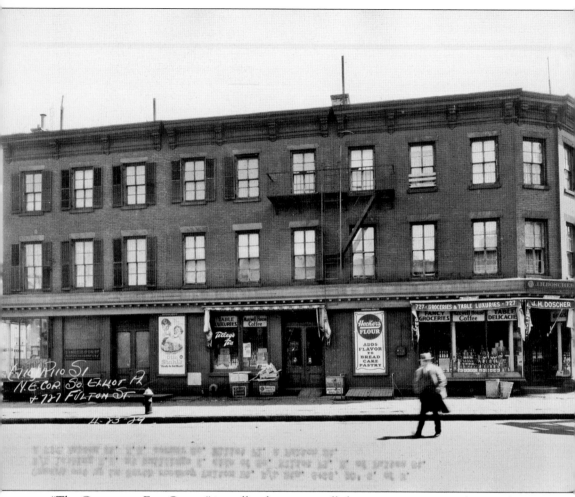

"The Gateway to Fort Greene" is really what many call the prospect one sees when striding up east, either from Lafayette Avenue or Fulton Street. These few storefronts on the short stretch of South Elliott Place between those two thoroughfares stand across from what is now Fowler Square, a small gore or triangle, where General Fowler's statue gazes out to his home site. (New York Transit Museum.)

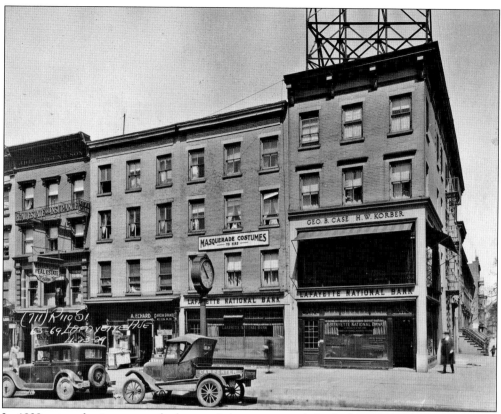

In 1929, a comforting street clock graced the way toward the Lafayette National Bank, then located at the northwest corner of Lafayette Avenue and South Elliott Place. The old "flivver" pickup truck parked in front was the type where the driver had to set the spark and throttle and then get out and crank. (New York Transit Museum.)

Wonderful wrought iron elements highlight this building in 1916 at the southeast corner of Lafayette Avenue and St. Felix Street. It was replaced by a coffin factory that now houses a Seventh-day Adventist grammar school. (New York Transit Museum.)

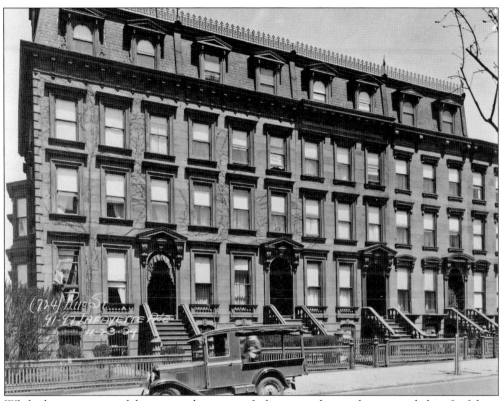

While their cornices and doorway pediments are Italianate in design, the mansarded roofs of these proud brownstones on the north side of Lafayette Avenue at South Portland Avenue are in the French Second Empire fashion. Gorgeous cresting surmounted them, all built by John F. Seeley in 1874. Together the brownstones appear to be a palazzo. Only the corner house remains; the others were replaced by a high-rise apartment called 99 Lafayette. (New York Transit Museum.)

In 1929, one-way traffic rolled east (as it still does) along Lafayette Avenue from South Portland Avenue to South Oxford Street. The prim and proper fences and all but one of the houses on that block on the left are gone now, replaced by two large apartment buildings, 99 Lafayette and the Griffin. Lafayette Avenue Presbyterian Church is on the right. (New York Transit Museum.)

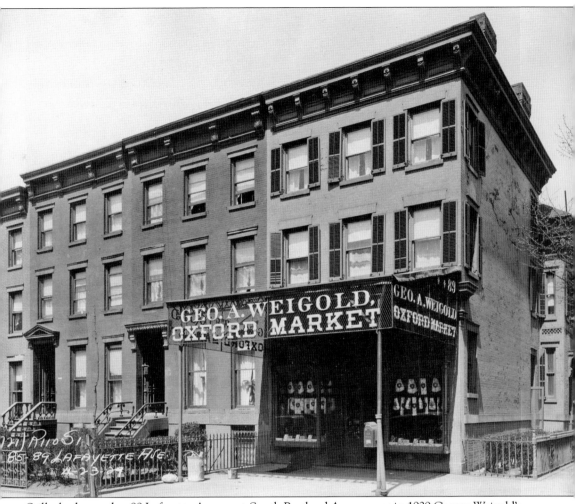

Still a bodega today, 89 Lafayette Avenue at South Portland Avenue was in 1929 George Weigold's Oxford Market. Beneath its covered entry it appears that wrapped, cured hams, bacon, and salami hung in the front windows. (New York Transit Museum.)

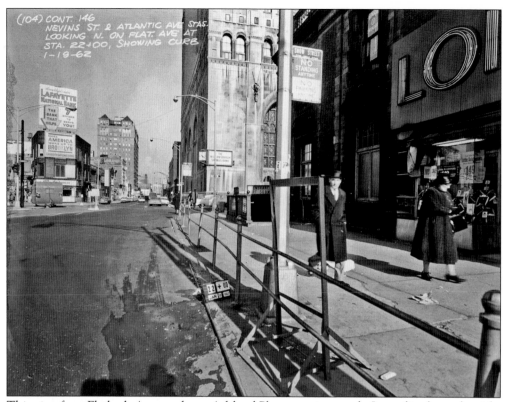

This view from Flatbush Avenue shows Ashland Place running north. Immediately on the right of Flatbush Avenue in 1962 was a Loft's restaurant in the Long Island Rail Road Terminal. The Williamsburgh Bank is just behind it. All the buildings and the Granada Hotel on the left have been leveled. (New York Transit Museum.)

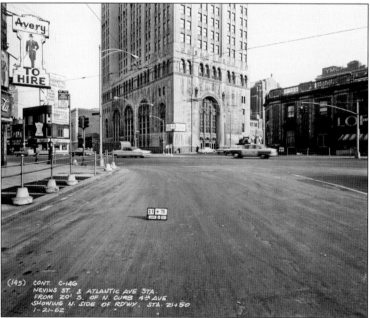

Morning coats and tuxedos could be rented at Avery's for people attending a big shindig in 1962. From Fourth Avenue, this view shows the Williamsburgh Savings Bank and the Long Island Rail Road Terminal at right. (New York Transit Museum.)

The buildings at the triangle of Flatbush Avenue, Ashland Place, and Hanson Place, seen here in 1962, are all gone now. "Make America Wake Up to Brooklyn," a sign for the Lafayette National Bank, sounds as if Brooklyn borough president Marty Markowitz wrote it today. (New York Transit Museum.)

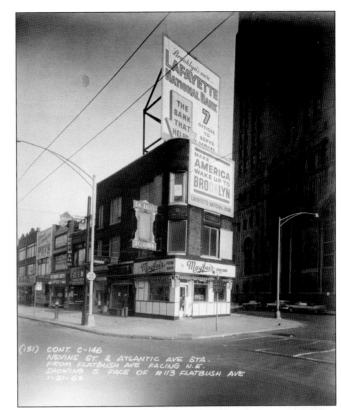

Manufacturers Hanover Trust bank has long vanished, along with its building facing Lafayette Avenue at the northern wedge of Flatbush Avenue and Rockwell Place. The spot is now a park where posies sprout in the spring. The Mark Morris Dance Group studios have replaced the building on the far right. (New York Transit Museum.)

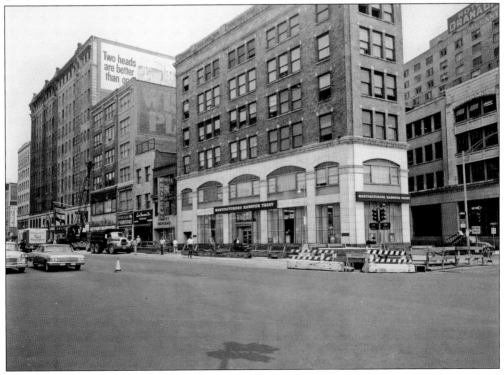

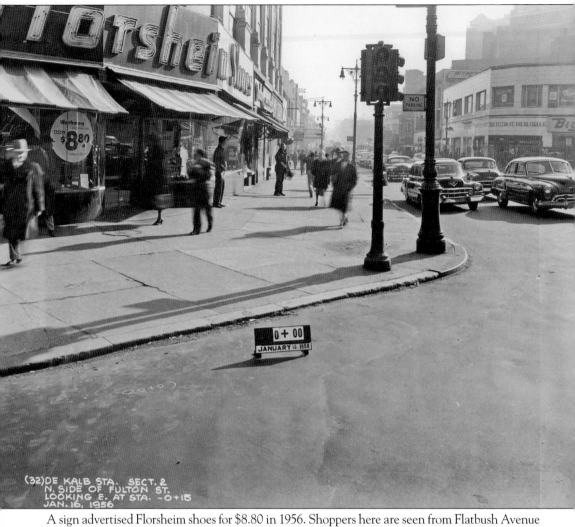

A sign advertised Florsheim shoes for $8.80 in 1956. Shoppers here are seen from Flatbush Avenue looking east up into Fulton Street. (New York Transit Museum.)

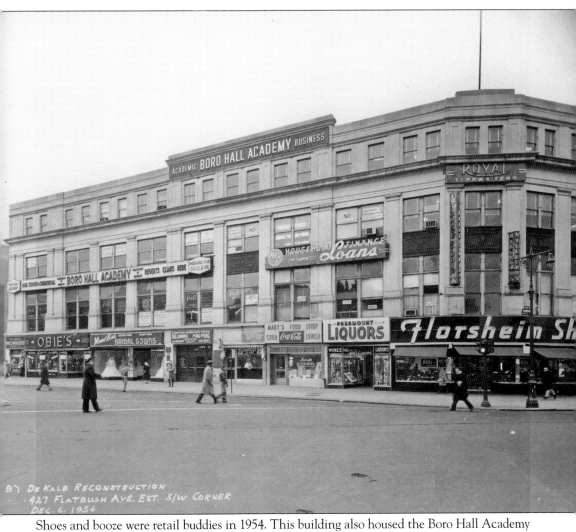

Shoes and booze were retail buddies in 1954. This building also housed the Boro Hall Academy for business studies, located at 427 Flatbush Avenue Extension. (New York Transit Museum.)

Located at an apartment house doorway on Cumberland Street, it is always nice to meet a new face. (Author's photograph.)

Called the "American Buddha," Fort Greene poet Walt Whitman (1819–1892) wrote in *Songs of Myself*: "I believe a leaf of grass is no less than the journeywork of the stars." His major work, *Leaves of Grass*, inspired both Ralph Waldo Emerson and Abraham Lincoln. Whitman also once edited the *Brooklyn Eagle*. When young, he looked like a dandy, but he effected a Santa Claus beard during the Civil War. (Brooklyn Historical Society.)

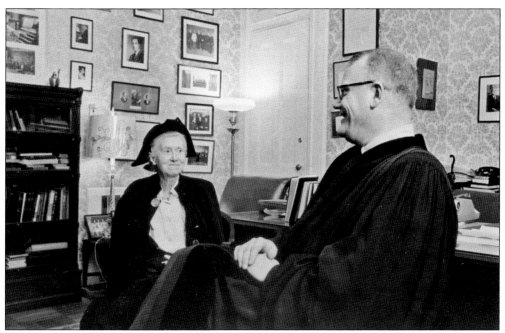

Pulitzer Prize–winning poet Marianne Moore, born in St. Louis, moved to Fort Greene in 1929. An ardent Brooklyn Dodgers fan, she wrote, "Baseball is exciting, almost like writing." She was also dedicated to the Lafayette Avenue Presbyterian Church, where she was seen here in the 1960s with Rev. George Licht Knight. (LAPC.)

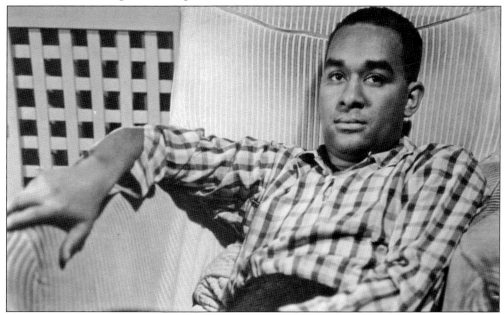

In Mississippi, young Richard Wright hanged his kitten, fussing and gasping; yet, he went on to write his 1938 breakout novel, *Native Son*, the first-ever Book-of-the-Month Club selection by an African American. While drafting it, Wright lived at 175 Carlton Avenue and usually walked to Fort Greene Park to do his jottings. Burned by McCarthy's terror, he moved to Paris before dying there in 1960. (Beinecke Library, Yale University.)

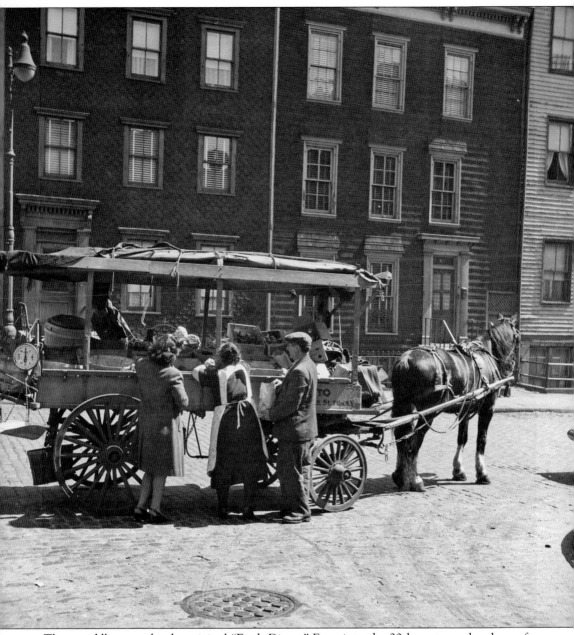

These peddlers may be the original "Fresh Direct." Even into the 20th century, the clang of a bell could be heard in the street, and locals would rush out to buy produce, pickles, or kerosene. Many of the itinerant peddlers were often immigrants from Italy. (Brooklyn Historical Society.)

Once a funeral home that served the Fort Greene area for many years, it became a tennis club with courts at the side. After being derelict for a time, it suffered a sad death when the Parks Department called for its demolition. The South Oxford Park is now located there between Atlantic Commons and Atlantic Avenue. (Author's photograph.)

There is always space on a building for a little artistry that deflects the woes of the day. (Author's photograph.)

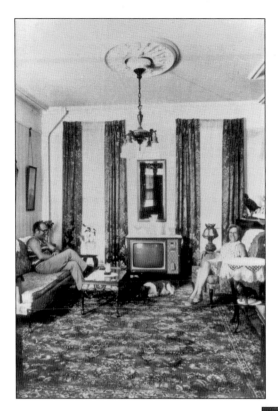

Sol, in his Archie Bunker undershirt, and his wife, Anne Codispoti, in her mid-1970s high skirt, relax in the front parlor of their 1853 Cumberland Street home. With the television turned off, the family dog sleeps in peace. (Dinanda Nooney photograph.)

Coached by Aaron Copeland and Igor Stravinsky, the musically talented Herbert Scott-Gibson (1928–1980) and his wife, Evelyn, a modern dancer, moved to Fort Greene in 1967. His foresight about preservation led to the historic designation of Fort Greene's fine homes in 1978 and later the founding of the Fort Greene Association. (Estelle Porter.)

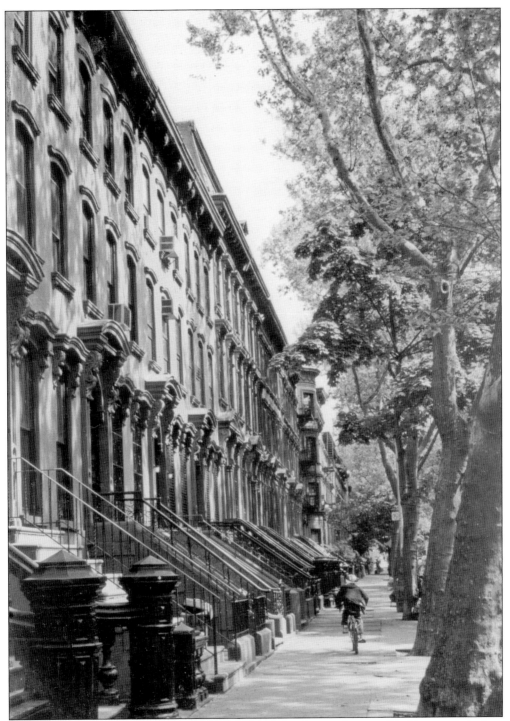

Through three appellations, the Revolutionary War's Fort Putnam became Washington Park, then Fort Greene Park. For the street east of the greensward, however, the second name stuck, even though it is a cleft from Cumberland Street on either side. Washington Park's brownstone houses, some with columned porticoes, have stood unperturbedly stately since the 1860s. (Author's photograph.)

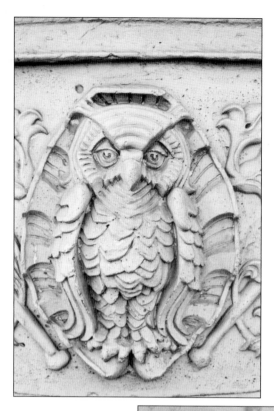

Wisdom results from seeing but never committing oneself to any brash pronouncements. That might be the thought of this owl, which has looked out at all the happenings along Fulton Street at South Portland Avenue since 1900. (Author's photograph.)

Style motivated Fort Greene residents in the Victorian era, as seen in this recreated parlor of an 1866 brownstone on Adelphi Street. It is now the home of Richard Burlage and Fritz Duteau. (Phoebe Ferguson photograph.)

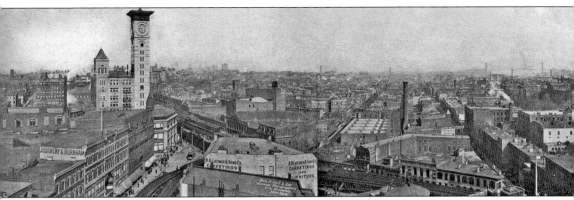

Dominant at the northwest corner of Nevins Street and Flatbush Avenue at the turn of the 20th century was the Fulton and Flatbush Storage clock tower. The Fulton Street Elevated line ran from the tower down to the lower right. Cowperthwaite's carpet store, located on Flatbush Avenue at the tower's base, burned in 1911, jeopardizing the storage company so that now only an enigmatic four stories of the tower remain. (King's Views of New York.)

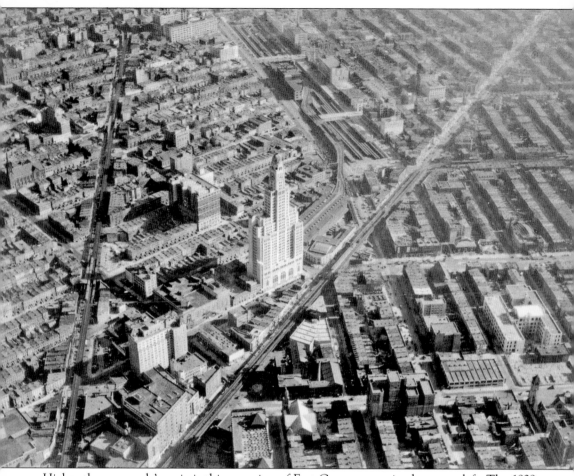

Higher than an eagle's aerie is this overview of Fort Greene, seen in the upper left. The 1929 Byzantine-fashioned dome of the Williamsburgh Bank is at the center. Halsey, McCormack, and Helmer drew the plans for its construction. (Source unknown.)

The house at 287 Cumberland Street is pictured as it appeared in 1922. Built in 1853, this house was occupied in 1918 by the Oliveri family, the father of which was from Calabria, Italy. His four children are on the stoop; the second, Anne, grew up, married, and raised a daughter here and after 64 years sold the house in 1982. (Author's photograph.)

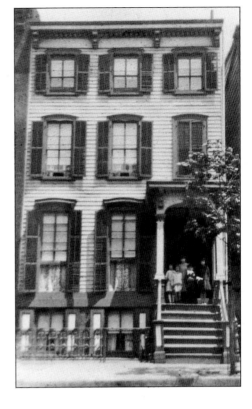

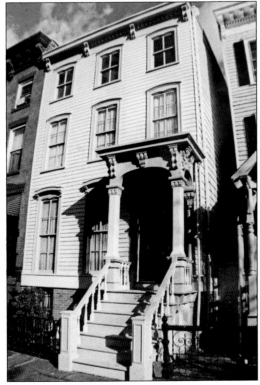

The 1982 buyers of the 287 Cumberland Street house, the late Alfredo Muglio and this book's author, restored the home in 1987 using Fort Greene Historic District guidelines. Many of its "new" details were repatterned from the 1922 photograph, and fretwork at the window lintels was recreated following ghost lines in the old paint. (Author's photograph.)

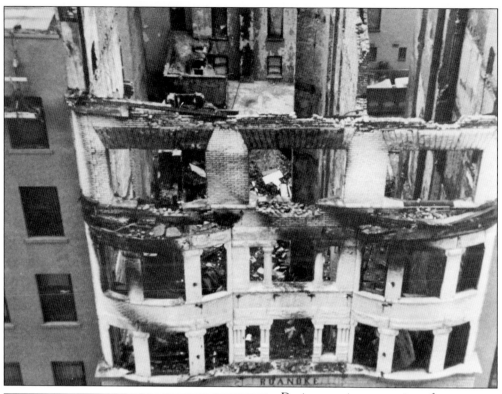

During a major renovation of the interior in the mid-1980s, a horrendous fire consumed the Roanoke Apartments at 69 South Oxford Street to nearly a total ruin. However, the sturdy brownstone and brick walls survived. (Source unknown.)

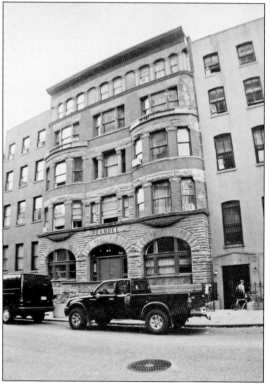

Attributed to noted architect Montrose Morris, this boisterous 1890 Romanesque Revival dwelling with rusticated stone was originally five stories high and was called the San Carlos. After a sixth story was added in the early 20th century, it became the Roanoke. Here it is restored after a fire in the late 1980s. (Author's photograph.)

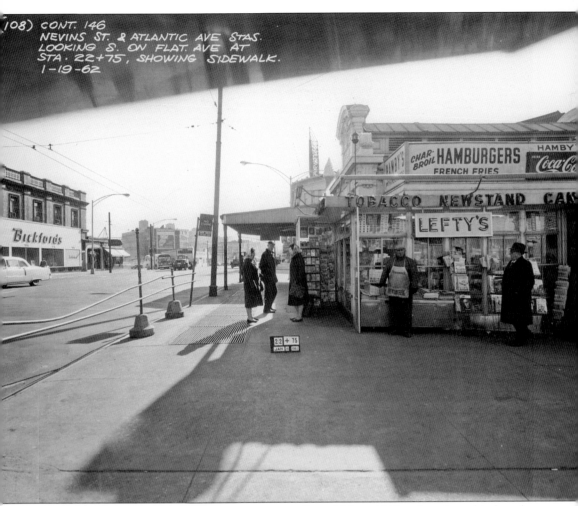

Harry's Hamburgers and Lefty's Newspapers were all available in 1962 at the subway kiosk at the triangle bounded by Flatbush, Atlantic, and Fourth Avenues. Bickford's restaurant was in the Long Island Rail Road Terminal building that has been replaced by Atlantic Center. (New York Transit Museum.)

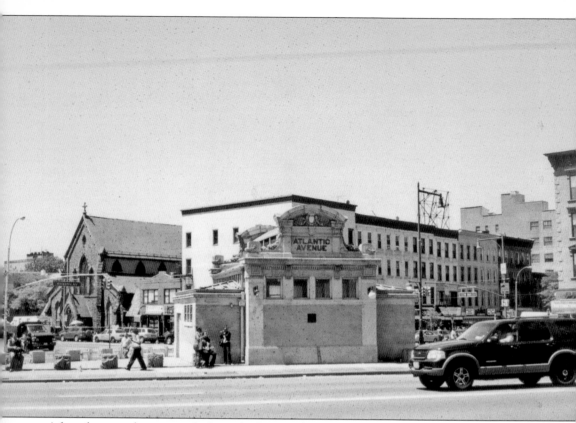

A lengthy reconfiguration of subway facilities and construction of a new Atlantic Terminal left this impish kiosk in limbo. It was removed and then replaced in 2004 in a pure state, now serving as a subway air vent. (Author's photograph.)

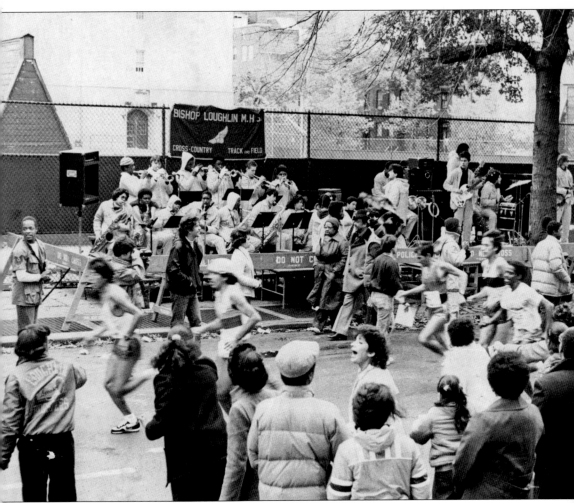

Every November since 1970 the New York Road Runners (NYRR) triumph with a famous, five-borough, 26-mile marathon that clocks through Fort Greene. In this scene from the 1980s, runners are pumping up Lafayette Avenue as the Bishop Loughlin High School band blasts out the thrilling music from Sylvester Stallone's film *Rocky*. (NYRR photograph.)

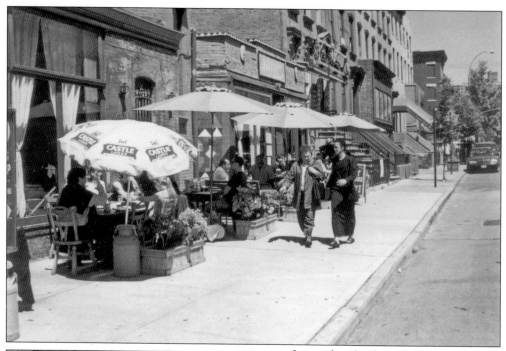

Long after the dicey doldrums of the 1960s through the 1980s, it is exciting again to see passersby and diners at outdoor restaurant tables. DeKalb Avenue, in particular, has become a "restaurant row." (Author's photograph.)

He looks ferocious, but he is safely tethered in stone to endure the vagaries of time and weather. The little critter stands in high relief on one of Fort Greene's mid-20th-century apartment houses. (Author's photograph.)

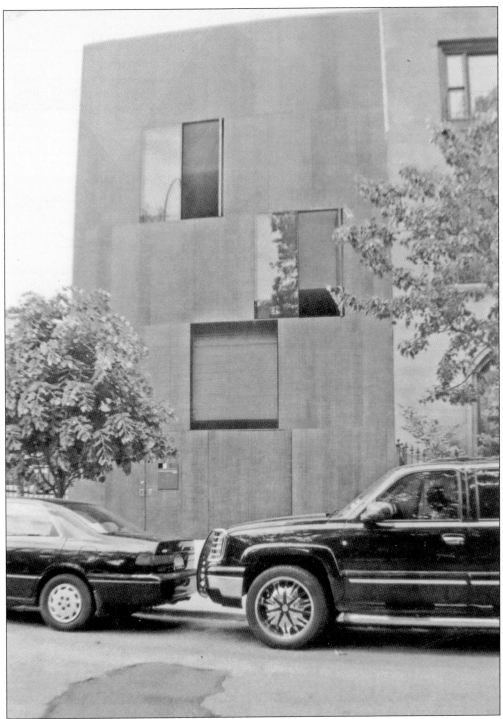

Modern minimalism is in-your-face in this studio for artists—some call it a Darth Vader house—that is sheathed with black polypropylene sheets. Inside the airy quarters, completed in 2005 at 208 Vanderbilt Avenue, are wondrous skylights, all the vision of the British architect David Adjaye. (Author's photograph.)

www.arcadiapublishing.com

Discover books about the town where you grew up, the cities where your friends and families live, the town where your parents met, or even that retirement spot you've been dreaming about. Our Web site provides history lovers with exclusive deals, advanced notification about new titles, e-mail alerts of author events, and much more.

Find *Your* Place in History.